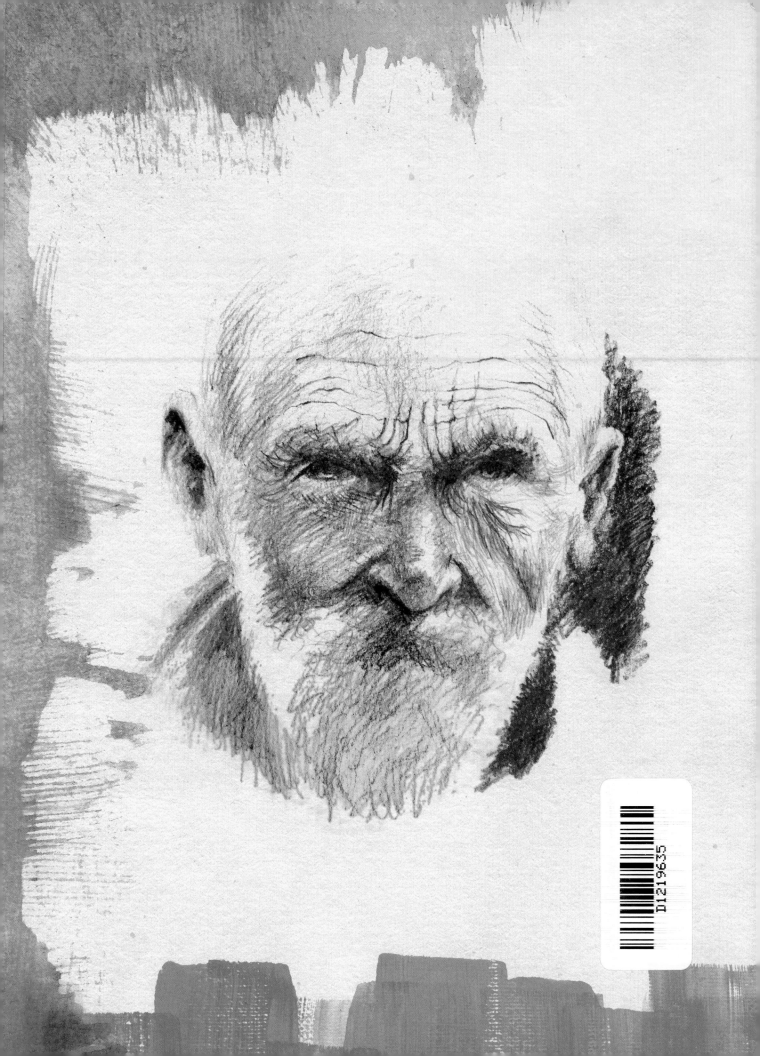

Published in Great Britain in MMXVII by
Book House, an imprint of
The Salariya Book Company Ltd
25 Marlborough Place, Brighton BN1 1UB

ISBN: 978-1-910706-65-7

SALARIYA
SCRIBO BOOK HOUSE SCRIBBLERS

1 3 5 7 9 8 6 4 2

A CIP catalogue record for this book is available
from the British Library.

Printed and bound in China.
Printed on paper from sustainable sources.

Visit
www.salariya.com
for our online catalogue and
free fun stuff.

QUICK DRAW™

Sarah Wimperis

People

BOOK HOUSE
a SALARIYA imprint

CONTENTS

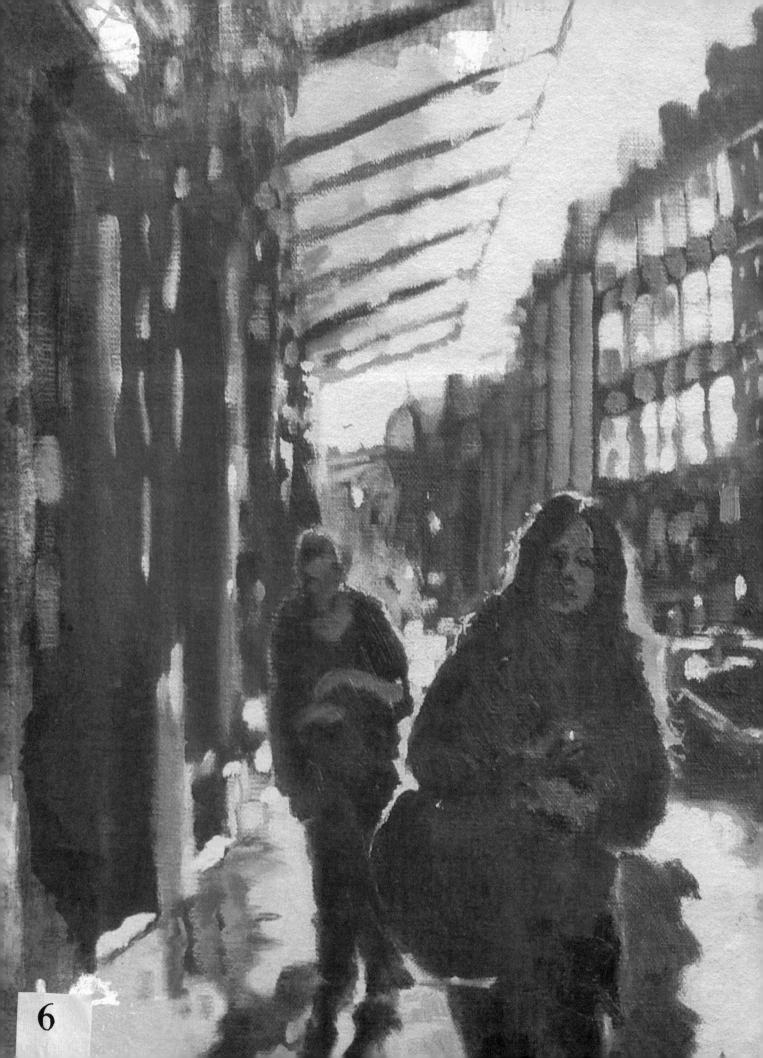

6

CHAPTER 1

INTRODUCTION

INTRODUCTION

Why draw and paint? Because it's good for you and everyone can do it. Drawing and painting is calming and relaxing. It can also be really exciting when it's going well, and can give you a great sense of achievement. It's a wonderful way to record your travels and is a source of great pleasure. You don't need to be specially gifted, either. All you need is confidence in your ability and that only comes through practice. If you want to improve at anything you must practise. You would hardly expect to be able to play a violin without training. Drawing and painting is no different – you have to learn.

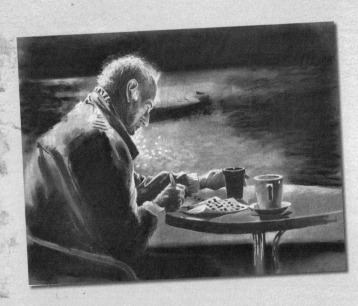

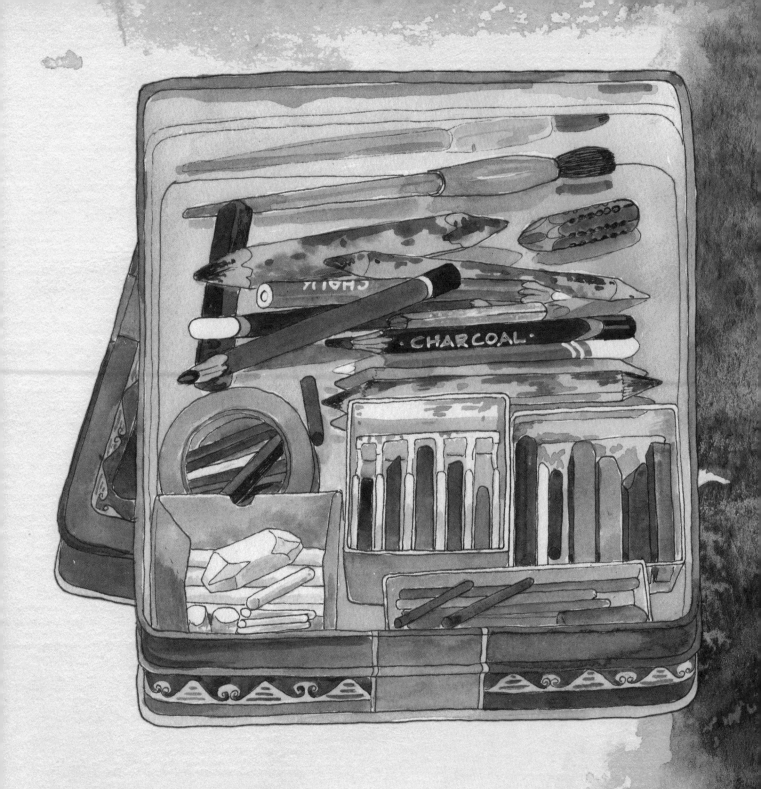

The materials you will need comes down
to personal choice. Practice and experience
will guide you. However, I suggest you begin
very simply with a 'pocket sketching kit' –
all you really need to get started is a pen or
pencil and a small sketchbook!

First of all, you don't have to do everything in this book. The idea is for you to find something that interests you enough to practise. The interest and desire to try something is the key to becoming more proficient. You will find that your confidence quickly builds and this will become apparent in your drawings and paintings. If you keep practising, that confidence will seep into your bones and you will start to really enjoy painting and drawing.

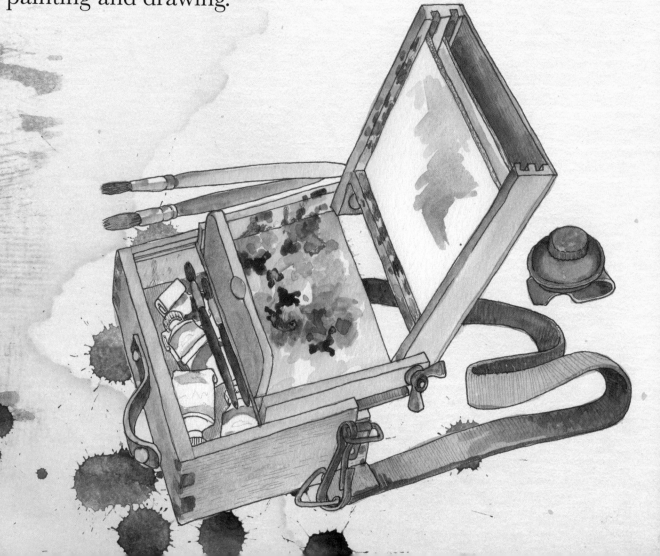

WHERE TO FIND INSPIRATION

There are hundreds of books on the subject of drawing and painting, a vast array of materials to choose from and more 'styles' of working than you can ever imagine. My advice would be to look around, browse the internet, and become acquainted with other artists' work. When you find a style that you really like or an artist whose work you admire, look into that genre of work to discover more artists you may like. Some may well have a book about how they work or they might have an informative blog or website. Whatever the source, try putting into practice what they teach. That will take effort and perseverance but the results will be worth it. Remember … Rome wasn't built in a day!

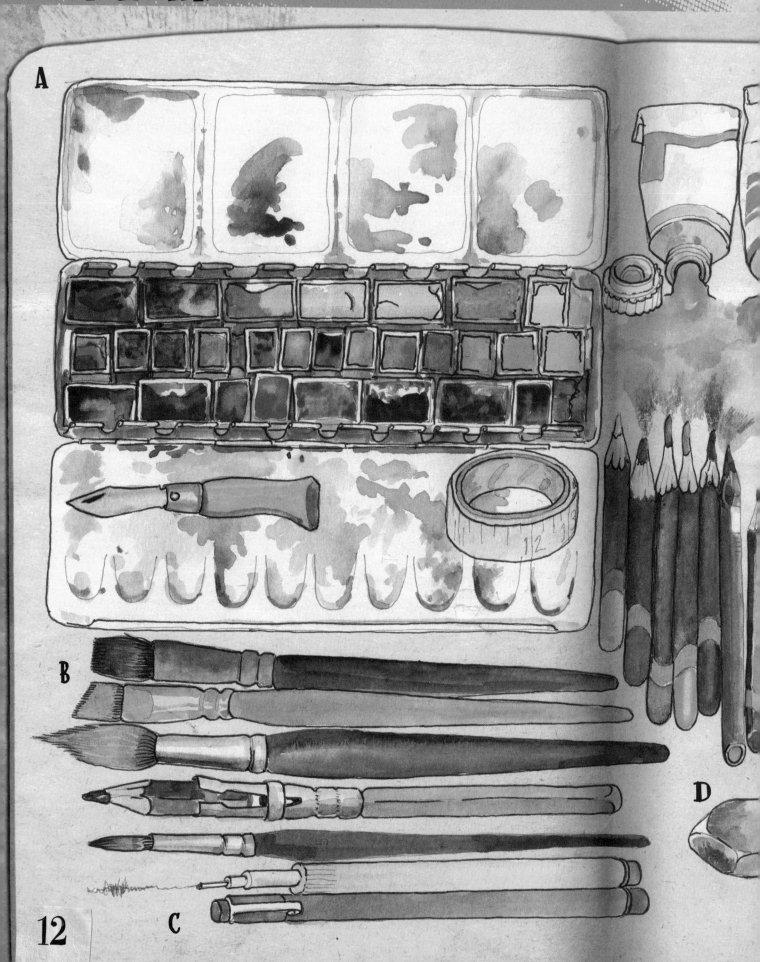

A

B

C

D

ARTIST'S TIP:

Ordinary watercolours are translucent (see-through); gouache is not. Try other kinds of paints, too.

A. Watercolour pans or solid blocks are easier to handle because they are laid out in a paint box. However, many painters prefer working from tubes. Watercolour sticks or markers are also available.

B. Paint brushes come in many shapes and sizes and are suitable for a wide range of media. They are made from synthetic fibres or natural hair as in squirrel or sable brushes.

C. Cartridge ink pens with oblique nibs are available in fine, medium and broad widths.

D. Coloured pencils come in a broad spectrum of colours. Water soluble versions can also be used to add a watercolour painting effect.

E. Pencils come in many different grades. The HB or 2B are standard sketching pencils. Choose pencils to suit your style and preference.

E

MATERIALS FOR SKETCHING

Materials for sketching need to be easily portable and suitable for capturing scenes on the go. Start simply with a sketchbook and pen and gradually build up your sketching 'kit' to suit your needs. Having a good array of useful equipment will let you draw more expressively, but if it's too cumbersome you will be less likely to carry it!

A lightweight sketchbook is ideal to take on your travels. Hard covers can be helpful as they give you a firm surface to lean on.

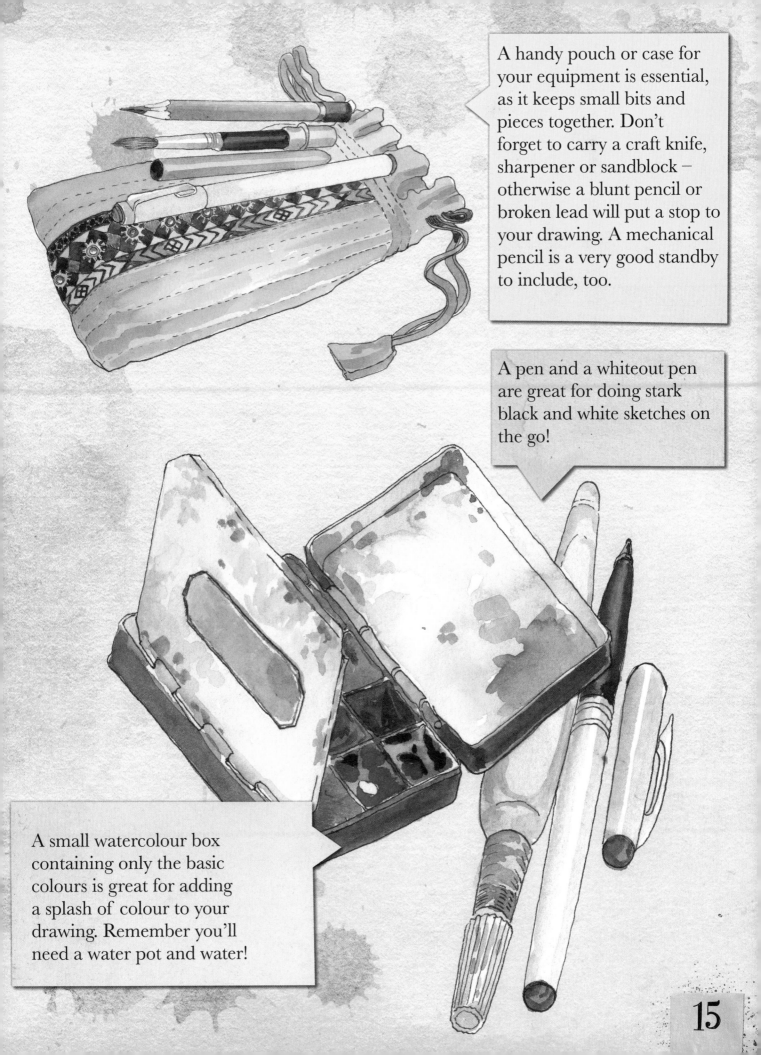

A handy pouch or case for your equipment is essential, as it keeps small bits and pieces together. Don't forget to carry a craft knife, sharpener or sandblock – otherwise a blunt pencil or broken lead will put a stop to your drawing. A mechanical pencil is a very good standby to include, too.

A pen and a whiteout pen are great for doing stark black and white sketches on the go!

A small watercolour box containing only the basic colours is great for adding a splash of colour to your drawing. Remember you'll need a water pot and water!

PROPORTIONS

roportion is about the relationship, or ratio, between the height, width and depth of a subject. In order to draw a believable likeness of any subject, you must correctly draw its proportional relationships. There are some basic rules for guidance but remember these are only loose rules. It is always better to observe and check by eye.

Compare height and width ratios by holding your pencil out at arm's length. Close one eye and use the length of the pencil to visually measure one proportion against another.

On average, a child's height will measure approximately four to five head lengths.

An adult's height will measure approximately five to eight head lengths.

ARTIST'S TIP:

In an adult face, the eyes are located roughly halfway between the top of the head and the chin.

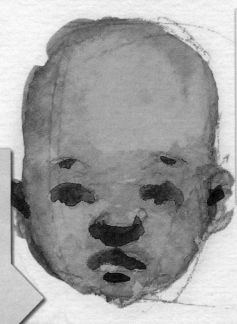

Faces have yet more rules: the face is roughly divided into three equal parts; hairline to eyebrow, eyebrow to the bottom of the nose, and nose to chin. The distance between the eyes is generally the width of one eye, or the same width as the nose and most of the mouth. Ears are positioned between the eyebrow and the bottom of the nose. However, this is simply a rough guide.

It is often easier to capture the essence of a figurative pose by starting off with a simple stick figure drawing. Once you have established the proportions and stance you can draw in the relevant shapes.

An infant's eyes are sited much lower on the head. All the facial features are much closer together although their relative scale remains the same. This is why a child's features appear larger than an adult's.

17

PENCIL FIGURES

Keeping a sketchbook with you at all times is vital if you want to develop your drawing skills. Practise drawing people wherever you have some time to sit and 'people watch'. You might be in an airport, a waiting room, a café, or relaxing on holiday. Get out your sketchbook anywhere and begin to draw – fill the pages with figures.

Materials:
- A5 size hardback sketchbook
- 3B pencil

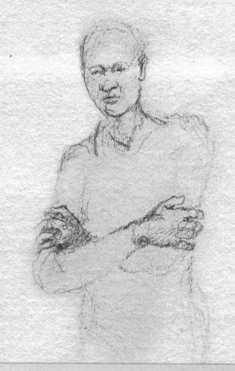

Start anywhere on the page but first look carefully at your subject. This is what I call 'looking consciously'. It's about being very aware of what you are looking at. How is the person standing – is their weight equally distributed? Or is most of their weight on one leg? How are they holding their arms? What kind of shapes does the figure make? Decide how you will draw it – your first line, the angle of the head and so on. Once you have done enough conscious looking then begin to draw. But remember … it's your drawing so do it your way. Ease yourself into drawing by filling a whole page with figures. Your pencil marks will become more confident with each drawing. With this first figure (above) I started with some guide lines for the head and then I drew the angle and shape of the shoulders. I was interested in his face and hands so I concentrated on them before moving onto other figures.

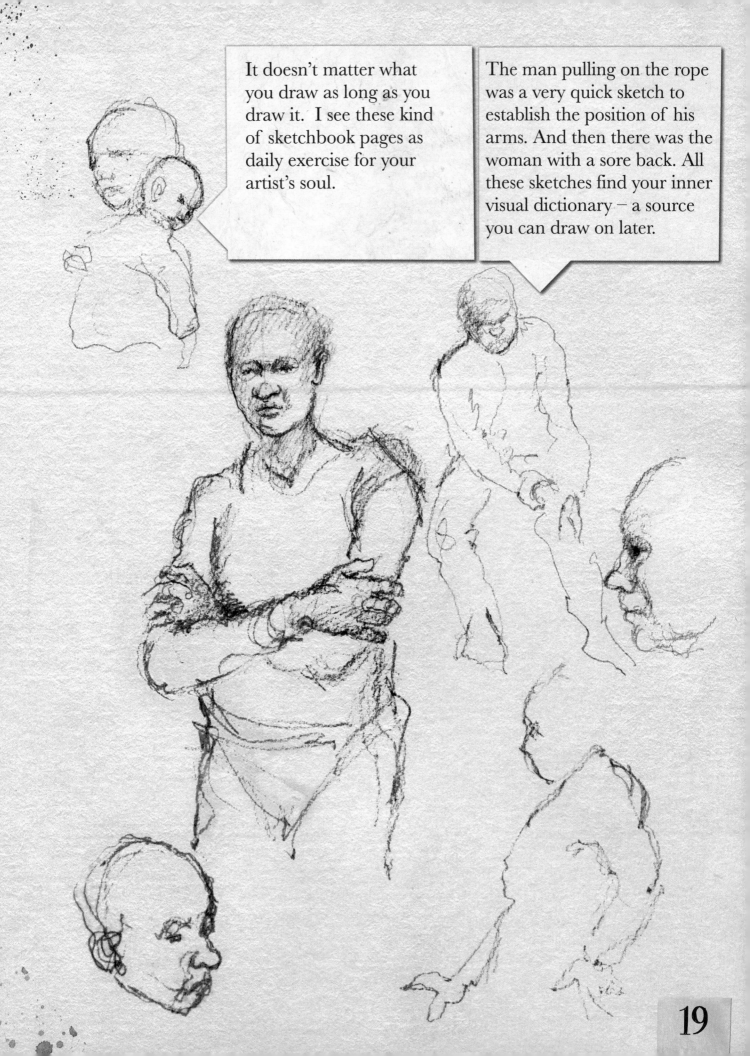

It doesn't matter what you draw as long as you draw it. I see these kind of sketchbook pages as daily exercise for your artist's soul.

The man pulling on the rope was a very quick sketch to establish the position of his arms. And then there was the woman with a sore back. All these sketches find your inner visual dictionary – a source you can draw on later.

19

EASELS

There are different types of easels, each to support the type of artwork you want to do and the size you want to make it.

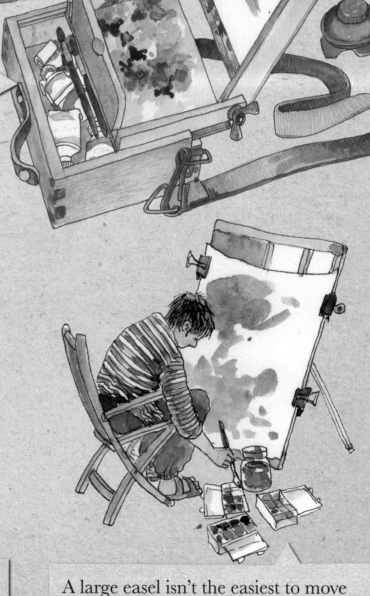

An artist's pochade box has a small compartment for materials and, in some, you can slot a board into the lid. Perfect for small works on the go!

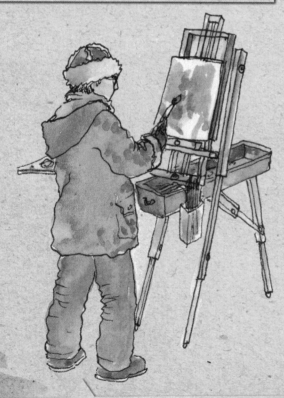

A French box easel has collapsible legs, plus a box in which to store art materials. This is useful for painting outdoors.

A large easel isn't the easiest to move around but is perfect for large scale works. Remember to bring a chair, as paintings can take a while!

CHAPTER 2

MAKING YOUR MARK

There are many ways of making your mark on paper. Each piece of equipment can be used in a variety of ways to create a myriad of different marks.

Some equipment is better for making precise marks for detailed drawing, while other tools are best used for larger, more expressive forms of artwork. It all comes down to experimenting with different materials to find out what suits you, and best meets the requirements of the artwork that you are trying to create.

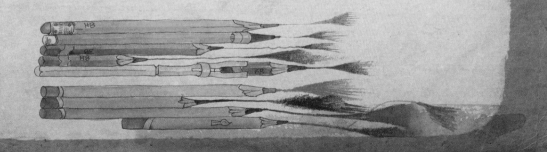

PENCILS

In England, in the mid 16th century, a shiny black substance was found underneath trees felled by a storm. At first the substance was thought to be lead, but it was a type of carbon called graphite. It was used for writing and drawing. It was very brittle so string was wound around it for protection. Later it was inserted into hollowed-out wooden sticks. In 1795, a French chemist called Conté mixed powdered graphite with clay, made it into sticks and hardened them in a kiln. Adjusting the mixture controlled the lightness or darkness of each graphite stick. Pencils range from 9H to 9B.

Graphite stick

Thinner sticks are coated in lacquer. Fat chunky ones are good for big expressive drawings.

Erasers

Flexible white plastic erasers can be cut into a sharp point if needed.

Kneaded eraser

A malleable rubber eraser lifts marks off the paper and can be shaped for detailed work.

Pencils encased in wood: the clay part of the mixture is the 'hardness' or 'H' factor of a pencil. The graphite part is its 'blackness' or 'B' factor.

Paper stump

For blending and softening pencil marks. Fingers can be greasy but if you don't have a paper stump handy…use them!

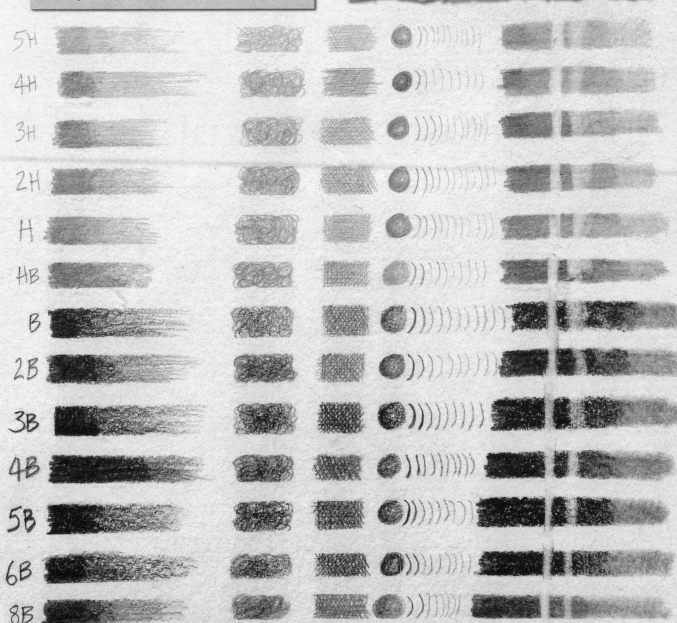

5H
4H
3H
2H
H
HB
B
2B
3B
4B
5B
6B
8B

THE RIGHT PENCIL FOR YOU

This will depend on your personality…honestly! If you like drawings to be neat and controlled then a harder pencil will suit you better. If you are a bit messy and expressive, then a softer pencil might be your best option. Try them out to find which you like best.

PEN AND INKS

Working with ink can be scary at first as you can't correct mistakes by erasing them. However, inks make very exciting marks that can create wonderful results. It is a great medium to add to your kit.

Whatever inks or pens you use, begin by making a whole series of different lines and patterns to try out your tools. Play around with them to find their potential.

Quill

QUILL: Make your own quill from a feather, and feel like Shakespeare! It will make some very interesting lines.

Bamboo pen

BAMBOO PEN: Makes very interesting marks, but does run out of ink quickly. Van Gogh used one!

BRUSH PEN: A good sketchbook tool! Line width can be altered by increasing pressure.

Brush pen

DIP PEN: These traditional pens can hold a variety of different nibs. They create interesting lines and surprising splatters!

ARTIST'S TIP:
Make sure your paper is thick enough or the ink may seep through it.

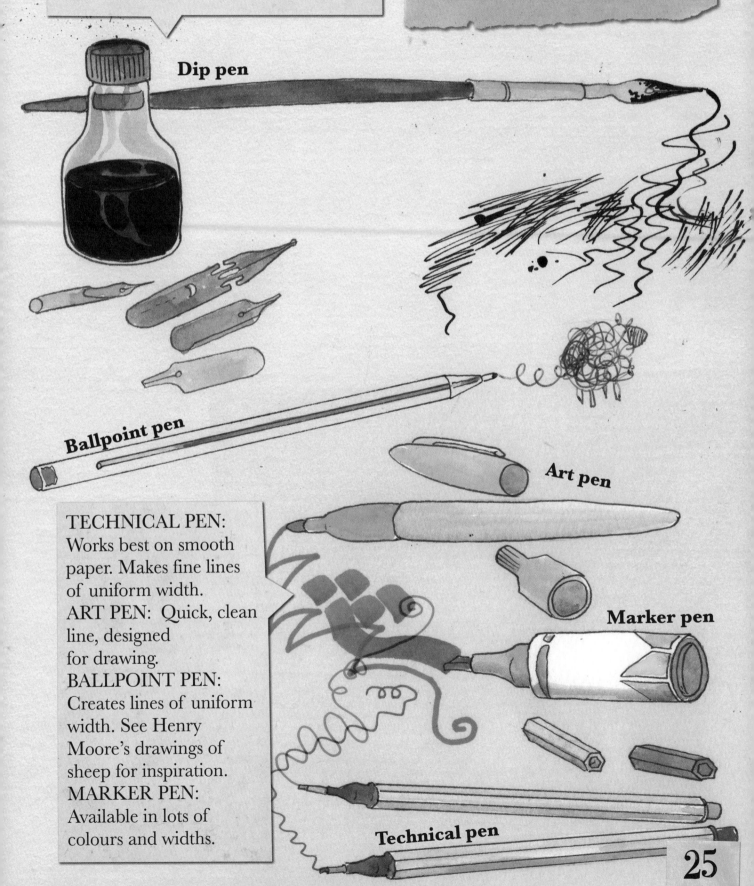

Dip pen

Ballpoint pen

Art pen

TECHNICAL PEN: Works best on smooth paper. Makes fine lines of uniform width.
ART PEN: Quick, clean line, designed for drawing.
BALLPOINT PEN: Creates lines of uniform width. See Henry Moore's drawings of sheep for inspiration.
MARKER PEN: Available in lots of colours and widths.

Marker pen

Technical pen

Vine charcoal, made from grape vine, is dark grey and harder than willow. Willow charcoal is made from willow branches. It is black, soft and easy to erase. Nitram charcoal is made from machined wood. It comes in different grades of hardness and can be sharpened to a fine point. It is less messy than willow or vine and makes a strong black mark that can easily be erased. Compressed charcoal is powdered charcoal held together with a binder of gum or wax. It is harder and often blacker than willow and vine. Because of this, it can be sharpened for detailed drawing. All charcoal drawings must be 'fixed'. No amount of fixative, however, will ever make them completely smudge-proof. They must be protected with tissue sheets or framed.

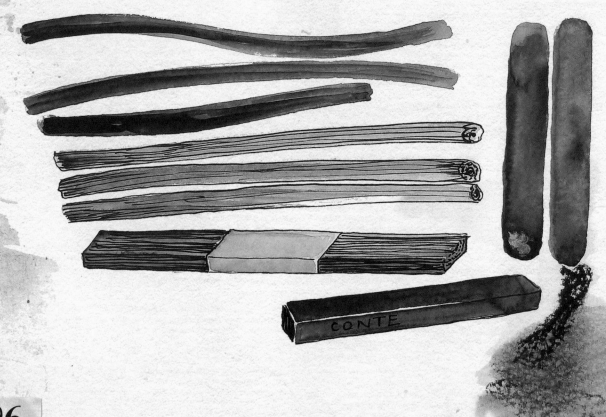

ARTIST'S TIP:

Artists often use small pastel drawings as studies for larger paintings.

Pastels are pigments mixed with a binder. Chalk was traditionally used as a binder, but other materials are now used. Pastels allow you to layer and blend vibrant colours to create a soft look. It has been a favourite medium of many well-known artists, including Manet, Degas and Renoir. You can buy sets that include dozens of colours but a set of 12 is ideal to start. You can also choose specific colour themes, such as earth tones or shades of grey. If you like the medium, buy more. Soft pastel sticks allow for better blending, while hard sticks are better for details. Working with pastels is like painting with a dry medium.

The history of paint and colour is quite fascinating. There is enough information available and so much to learn about colour that several books could be dedicated to this topic alone.

It is hard not to be overwhelmed by the vast choice of wonderful colours available in most mediums. It can be extremely interesting to look at the 'palette' or colour choices of your favourite artists, and this may well influence the colours you choose to buy. A good way to test out your colours is by painting a small colour wheel.

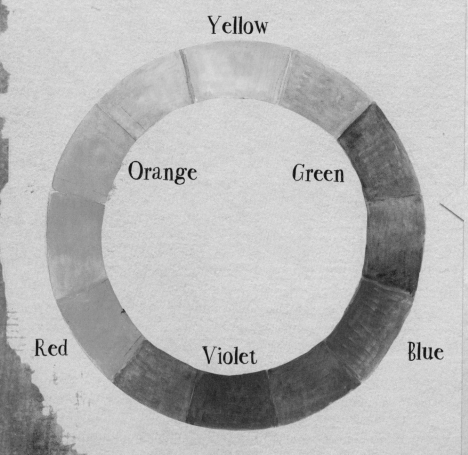

Yellow
Orange
Green
Red
Violet
Blue

Divide a circle into twelve sections. Paint the top part **yellow**. Moving clockwise, miss three spaces and paint the next one **blue**. Repeat this gap and paint the next one **red**. These are the three **primary** colours. All colours are mixed from them. An equal mixture of two primary colours will create a **secondary** colour:
Yellow + Blue = **Green**
Blue + Red = **Violet**
Red + Yellow = **Orange**
The remaining colours are a mixture of the primary and secondary colours adjacent to it on the wheel.

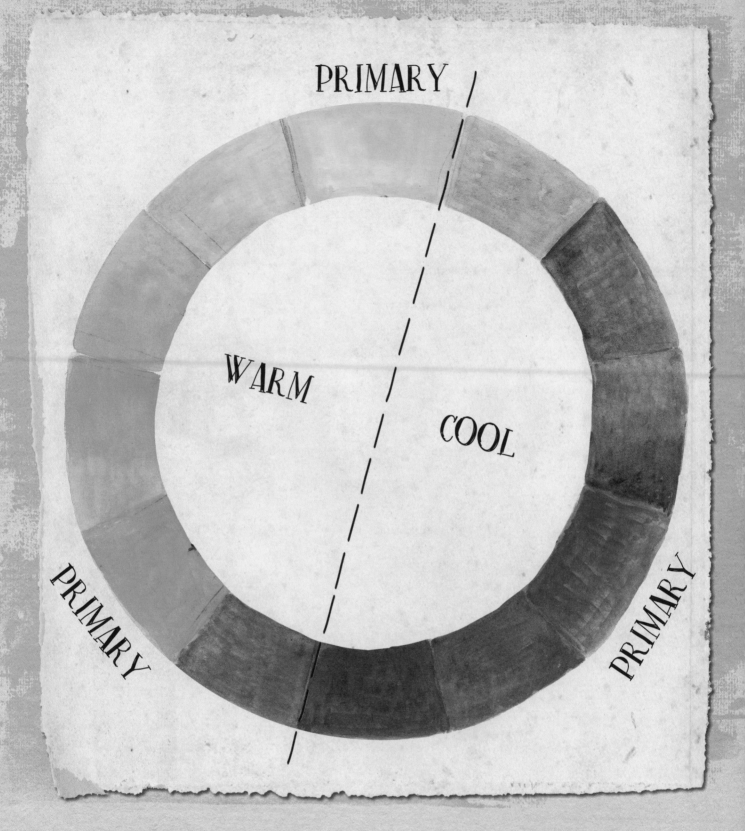

PRIMARY

WARM

COOL

PRIMARY

PRIMARY

Colour is also thought of in terms of its warmth or coolness. If you draw a diagonal line through your colour wheel (as shown) the warm colours are on the left side and the cool colours are on the right.

Warm, energetic colours seem to move forward and appear larger. Cool colours are calmer. They seem to move back and appear smaller. Artists use this aspect of colour to convey distance and mood in a painting.

29

MIXING AND USING COLOURS

Mixing colours is the way to create all the varied tones you will need when painting. Experiment with mixing, but be careful not to add too much of one colour to another in one go or it will dominate. Also, if you mix too many colours together you will invariably end up with a muddy brown!

Watercolour sticks

You can use these to alternate easily between drawing and painting. Apply the dry sticks to your surface, then wet with a brush to create soft washes.

Different paints

Different types of paint can influence the way colour mixes. However, the same principles of mixing generally still apply even if you are working with diluted washes.

Colour mixing guide:

This grid shows the results of each individual colour (top row) being mixed together with each successive colour in the left-hand column.

ARTIST'S TIP:

Buy the best materials that you can – it does make a difference. However, if the expense inhibits your output, consider opting for cheaper materials!

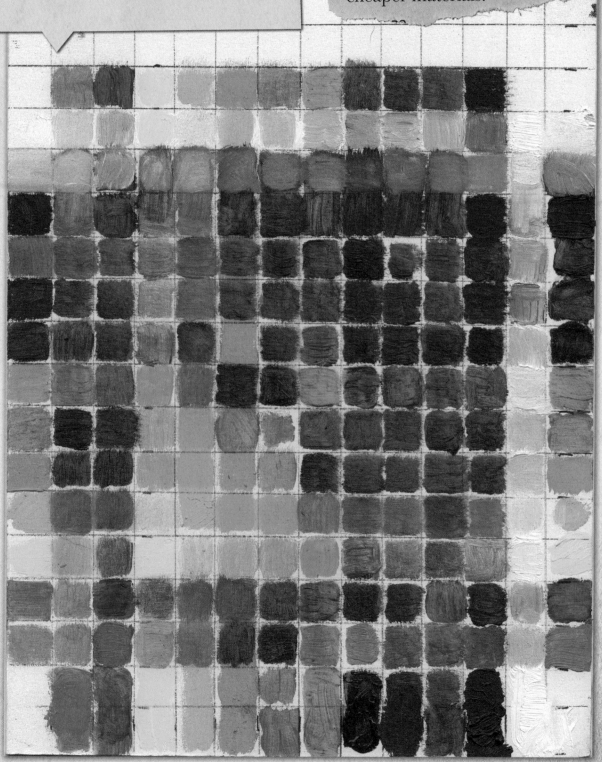

BRUSHES

Paintbrushes range in size, shape and structure. Each can make a different mark or create a different effect depending on the paint or technique that is used.

Softer brushes are good for thinner, more fluid paints, such as watercolours, and stiffer brushes are good for thicker paints like oils or acrylics.

It is best to experiment with different types of brushes to find out what suits you best and works well with the style of painting you are trying to achieve.

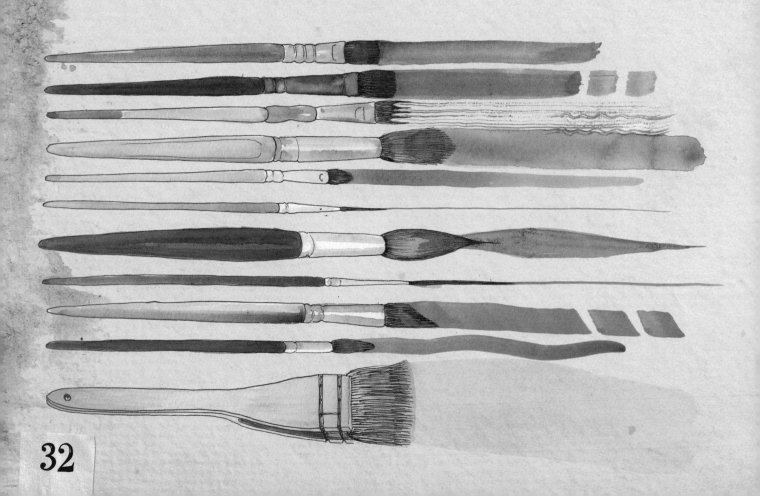

CHAPTER 3

PORTRAITS, HANDS AND FEET

Try drawing studies of different parts of the human body so that you can get to grips with the challenges presented by each. Once you've developed your skills in depicting the body's many component parts, you will then find it much easier to draw entire human figures of all ages in different poses and settings.

Always remember:
- Always look more at your subject and less at your paper.
- It's your creation – you are the boss!
- Practice will make you a better artist – it's up to you!
- It's okay to use photographs for reference.
- Enjoy what you are doing.

HANDS

Hands are tricky to draw and can undermine your confidence in your drawing and sketching. You often see drawings where the hands are hidden or simply drift into an unfinished obscurity. Understanding a little about the anatomy and construction of a hand will really help you to get them right.

Materials:

- Smooth, hot pressed paper (300gsm)
- Ink drawing pen
- Watercolour brush (round)
- Watercolour: burnt sienna

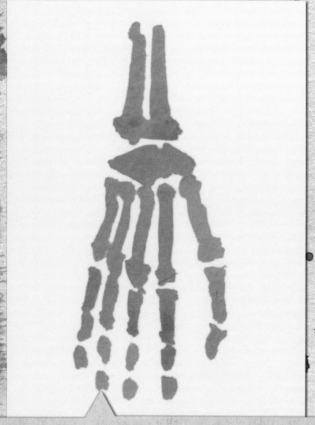

Paint a simple skeleton hand with two bones connecting it to the arm. The hand is a collection of small bones. Paint each digit with a blob to indicate the knuckles. Fingers have two joints but the thumb only has one.

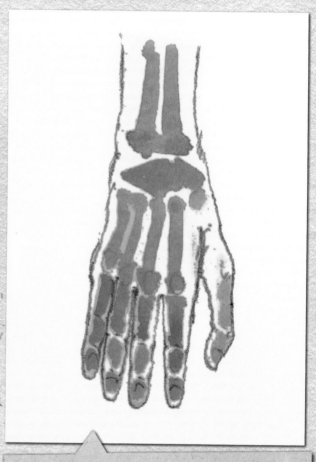

Once you have the underlying structure in place, start drawing in the outline of the hand using a pencil line.

Get to know the proportions of a hand. The width is approximately half the length of the whole hand.

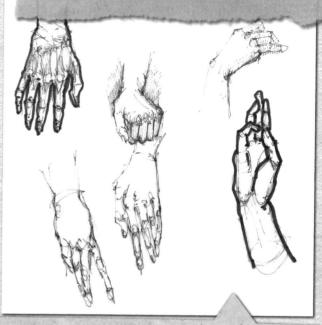

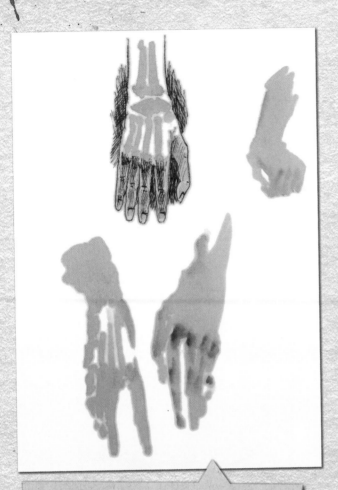

Try a few ink doodles. Draw your own hand in different positions to see how it moves. Get to know your subject!

Ink in the pencil lines and then start another sketch of the hand in a different position. Fill the page with hand drawings.

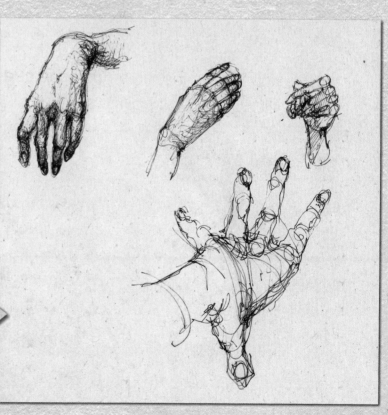

Try copying hands from paintings or drawings. I used to draw endless Arthur Rackham hands and feet – he was particularly good at them. Practice makes perfect!

CHARCOAL OLD WOMAN

This technique uses a putty rubber to draw into charcoal. It's a bit messy but quite good fun and it will attune your eye to seeing tones better.

Materials:

- Inkjet paper (265 gsm)
- Compressed charcoal
- Chalk
- Putty rubber

Start by rubbing charcoal over the whole sheet of paper. Blow away all loose dust.

Use the warmth of your hands to mould the putty rubber to shape it into a drawing point. Then use it to lift off the charcoal from the lightest parts of the face: the nose, the top lip and the chin.

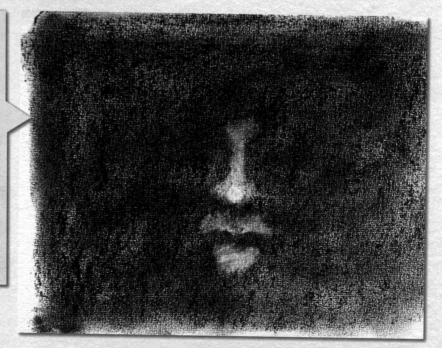

ARTIST'S TIP:

Rest your drawing hand on scrap paper so that you don't smudge your drawing.

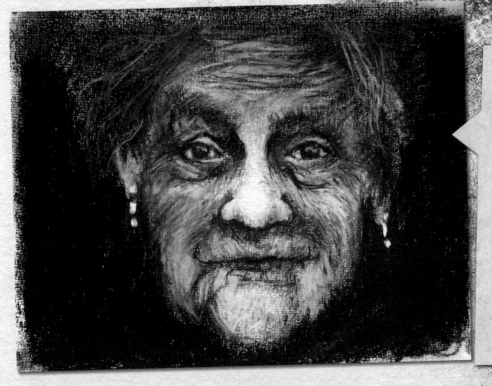

Continue working in this way to draw the shape of the head. Use the rubber to create directional strokes that follow the soft contours of the face.

Once the shape of the head is established, start drawing into the face with the compressed charcoal, to redefine some areas with darker tones.

Now add solidity by using chalk. Emphasise lighter areas with cross hatching to build up the form of the head. Keep working with the rubber, chalk and charcoal until you have the intensity of drawing required. See how solid and realistic the final drawing can become.

CRAGGY FACE IN PENCIL

It's fun to explore the potential lights and darks of a pencil line. It is well worth getting to know the range of a pencil to enable you to utilise it fully in each drawing. This craggy old face can be expressed perfectly using a wide mixture of lines to convey its deep, shadowy contours and areas of highlights.

Materials:
- Inkjet paper (265 gsm)
- 2B, 5B and 6B pencils
- Putty rubber

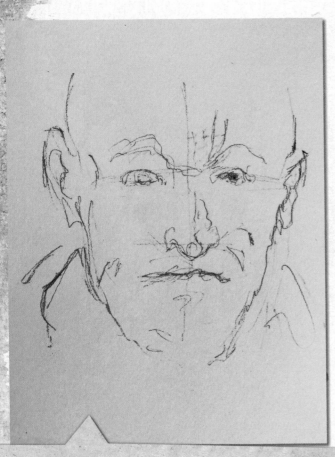

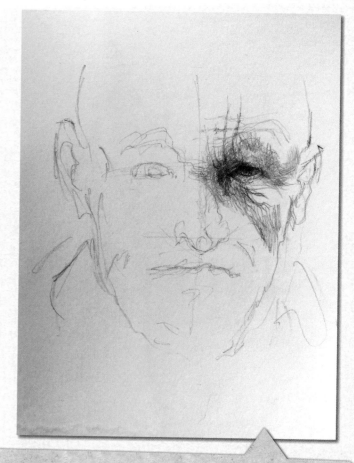

Begin by lightly drawing in guidelines to get the facial proportions correct. Then dot in some reference points like the pupils of the eyes, the ears and the nose tip. Once this is done you can add more detail.

Once all the features are in place, start building up the darker tones like the deep shadows around the eyes. I use layers of slightly wobbly cross-hatched lines to create the gradation of tones that I want to achieve.

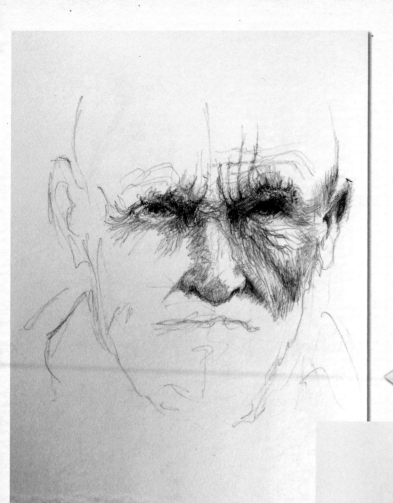

ARTIST'S TIP:

Varying the tonal quality gives depth and creates a more 3D aspect to the face.

Keep going with lots of scribbly lines to describe the surface contours of the face. The skin is weathered and the nose is knobbly – think of how these might feel to the touch. This can help you interpret your drawing.

In areas where light hits the face, go easy on the pencil. Lessen the pressure and let the pencil marks gently diminish. A hard line is only used in places where there is a dramatic light contrast.

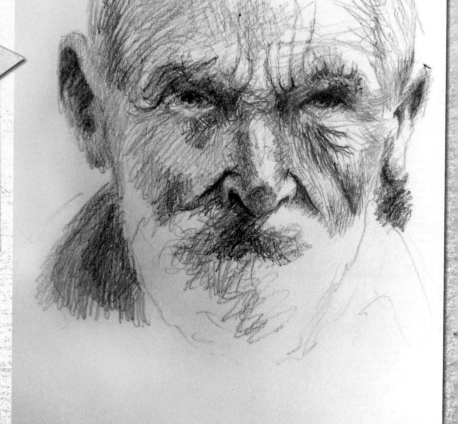

39

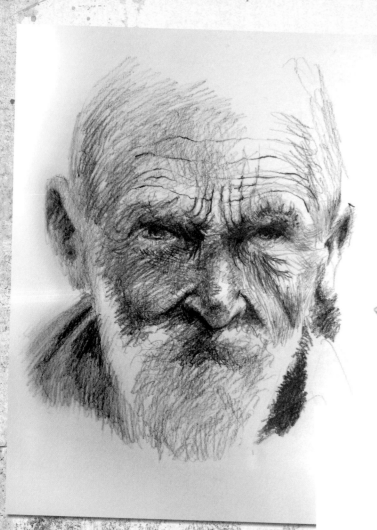

Add the lines of his face and deepen the shadows. Remember to make at least some of your lines follow the form of his features, somewhat like the contour lines on a map. Imagine that a Martian might want to build this face – would your drawing provide any 3D information?

Add dark areas within the folds of the ears and around parts of the head. Heavy outlines are unnecessary as our brains pick up tonal cues in the drawing to fill in any missing lines – like magic!

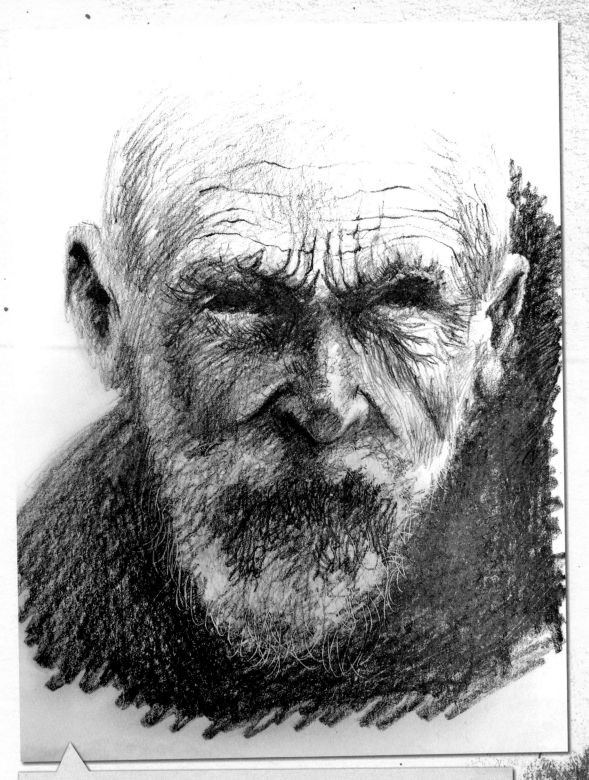

How do you draw fine white lines on a wispy beard? Well … it comes down to a clever trick. By pressing the pointed end of a wooden toothpick into the paper, you can create linear indents. Now add shading to this area using a soft pencil. The indented lines will remain white against the dark shaded area.

PENCIL PORTRAIT

This high-contrast portrait was achieved simply with a range of soft, dark pencils and a putty rubber.

Materials:

- Inkjet paper (265 gsm)
- 2B, 5B, and 6B pencils
- Putty rubber

Start by lightly sketching in the profile. A light touch is preferable at this stage as it allows you to make corrections as the drawing progresses.

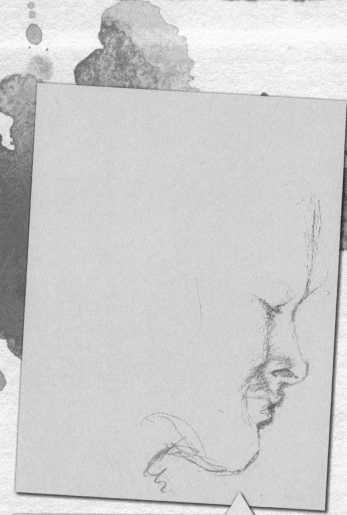

Now pencil in some dark tones using gentle scribbling lines to keep everything soft, as you feel your way into the drawing.

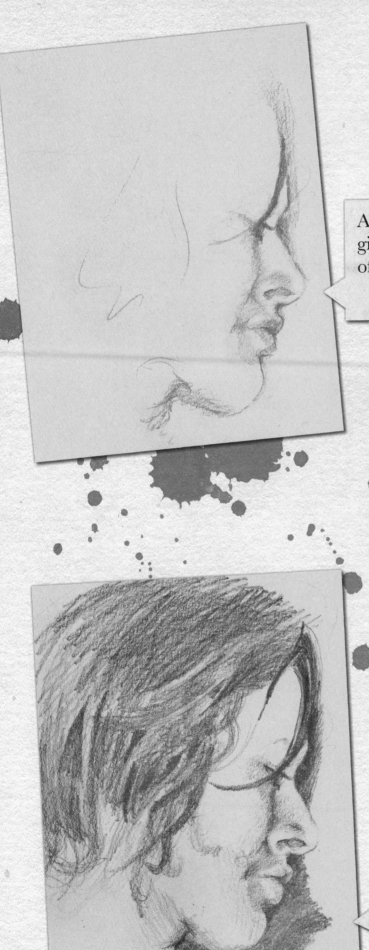

Adding a few dark touches now will give you some reference points in terms of tonal range.

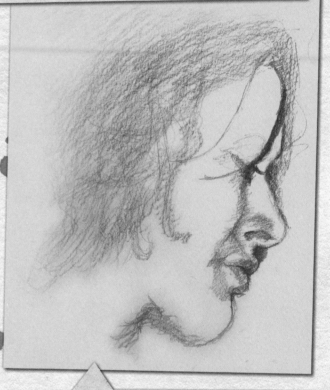

Now begin to build up the dark, contrasting background to emphasise the profile. Work in the darker tones of the hair, too.

Block in the larger directional sweeps of the hair to add shape and form.

Build up the pencil lines to increase the dark tones of the hair. Allow the front edges to merge into the background tones.

Pick out highlights with the point of a putty rubber. Warm the rubber in your hands and work it into a pointed stub. Constantly reshape it as you work.

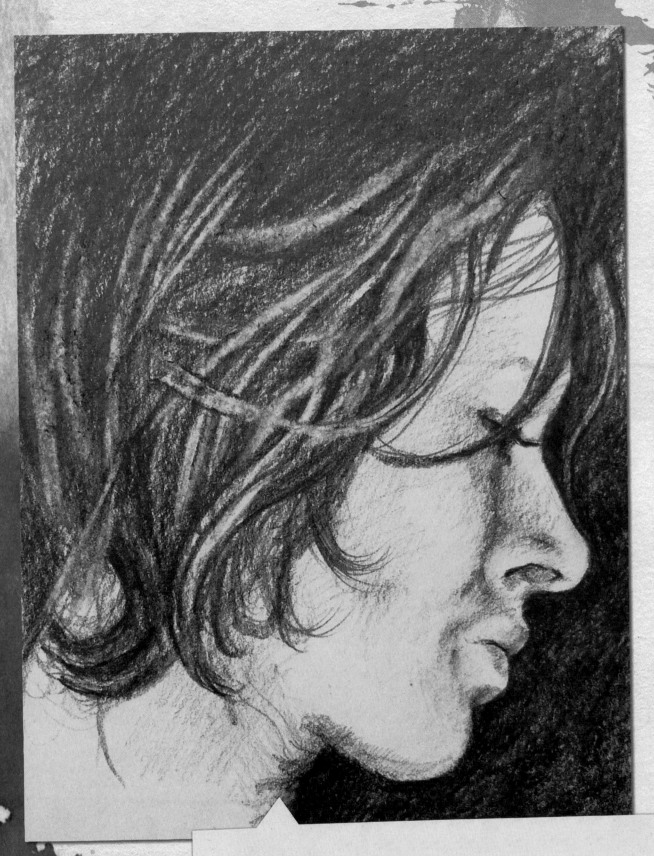

Adjust the light and dark tones until you are satisfied with the final result. I decided to remove some of the tone on the face. I also changed the shape of the lower lip slightly as it was curving round more than I had intended when I initially drew it.

45

OIL PORTRAIT

This large portrait is done in oils. Paintings don't always go to plan. However, you will see here that all is not lost. You can almost always re-invent your painting!

Materials:

- Stretched linen canvas (80 x 60 cm)
- Charcoal pencil
- Oil paints: titanium white, cadmium lemon, yellow, orange and red, alizarin crimson, burnt sienna, ultramarine blue, cobalt blue, ivory black, Naples yellow
- Turpentine

Start by making a few sketches to help you make decisions about your painting. Preliminary sketches also help to fix your subject in your brain.

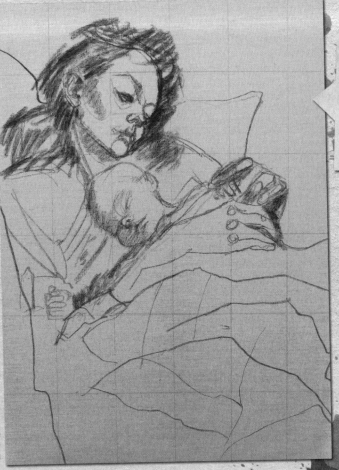

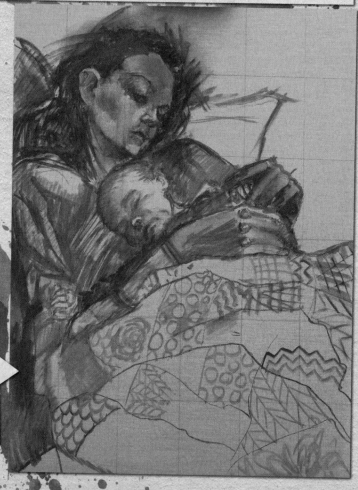

Grid up your canvas. I divided the height and width by six. This allows me to see the canvas in thirds, which helps me with composition.

ARTIST'S TIP:

Oil painting takes a while to dry but this does give you the opportunity to revisit your painting to make further changes if required.

I drew my first sketch with charcoal and then painted over it with a diluted mix of burnt sienna and French ultramarine. I marked out the quilt patterns and tonal values with a mix of paint and turps. Wipe back lighter areas with a rag.

Start blocking in colour. I don't worry about detail at this stage as I will be over-painting this later. If you find things getting a bit fiddly, just move on.

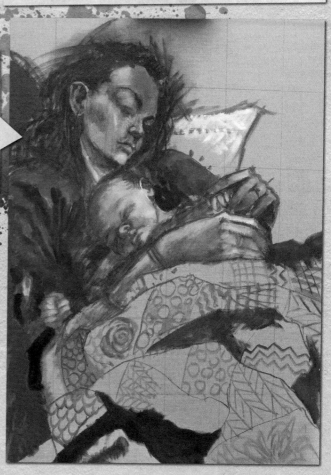

Start sculpting the shapes out with the paint. Remember the direction of your brushstrokes as well as your choice of colours.

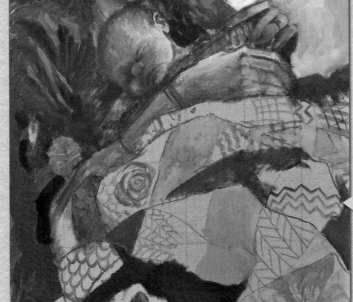

I really wasn't happy with my painting so I left it for a few days, gave it a wash of titanium white and began again.

A new start: a fresh drawing and then back to blocking in the colour again.

I gradually adjust the colours by layering one colour on top of another until I achieve the result I want.

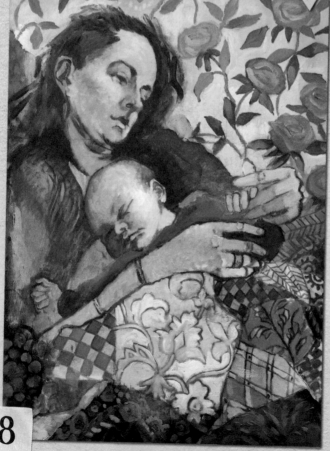

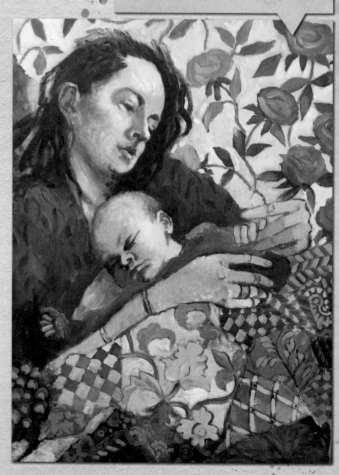

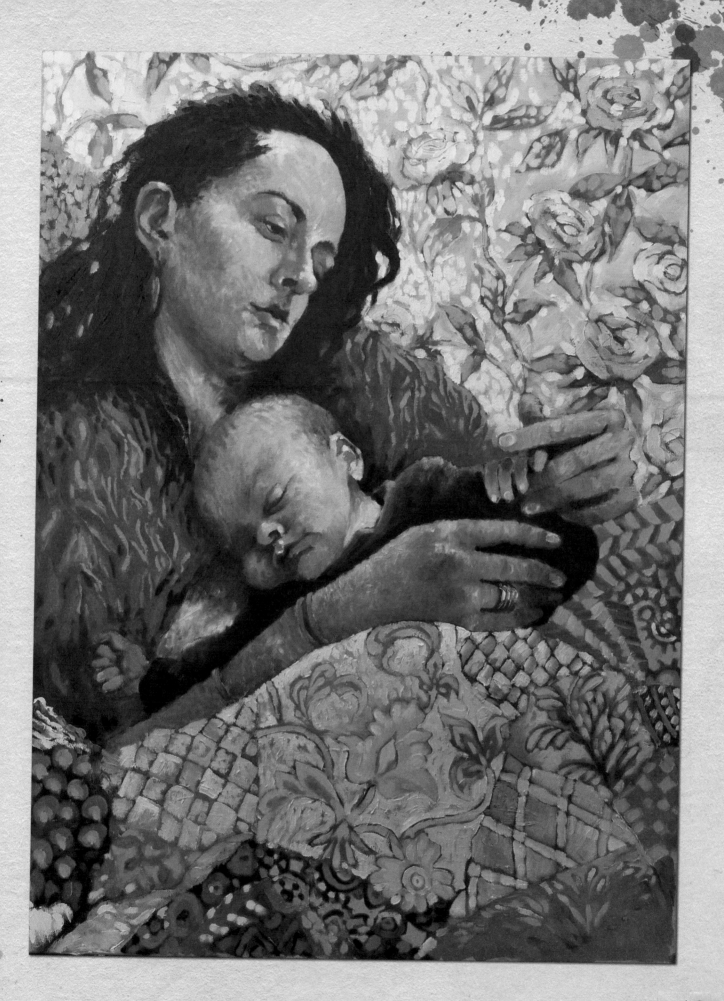

49

SELF PORTRAIT IN OILS

Your best model is yourself. You won't get bored, you won't fidget, and you don't have to please or flatter your sitter. Draw and paint yourself to experiment with portrait painting. This oil painting is on stretched linen.

Materials:
- Stretched linen canvas (60 x 40 cm)
- Oil paints: titanium white, cadmium lemon, yellow, orange and red, alizarin crimson, burnt sienna, ultramarine blue, cobalt blue, ivory black, Naples yellow

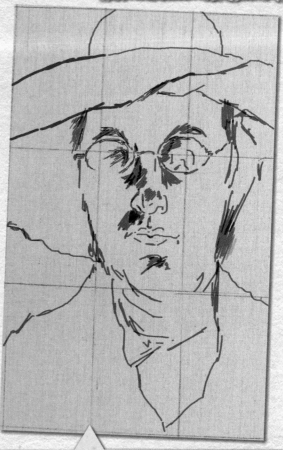

I gridded my canvas, dividing height and width by three. Using thirds helps me to compose the painting. I like to use a very loose mix of burnt sienna and French ultramarine, thinned with turpentine to draw the image onto the canvas.

I start with a few rough sketches to plan out the canvas, concentrating on the bigger shapes in the painting. This helps 'fix' things in my mind. I wore a large hat so that most of my face was in shadow.

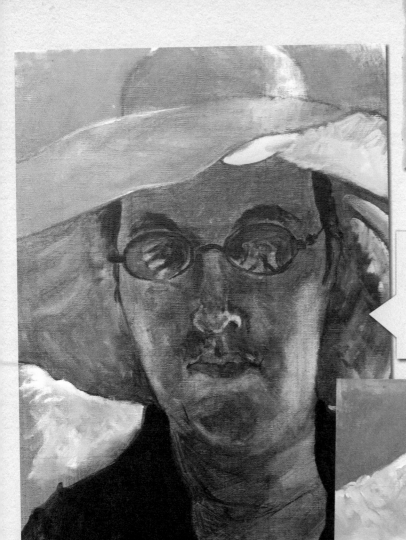

ARTIST'S TIP:
Study some photos of yourself to try and recognise your most defining features.

I now begin blocking in large areas of colour to create a tonal base for my painting.

After this first blocking-in stage, I add more colour. I will be painting over most of this again so these are base colours only that will peep through the top layers of paint.

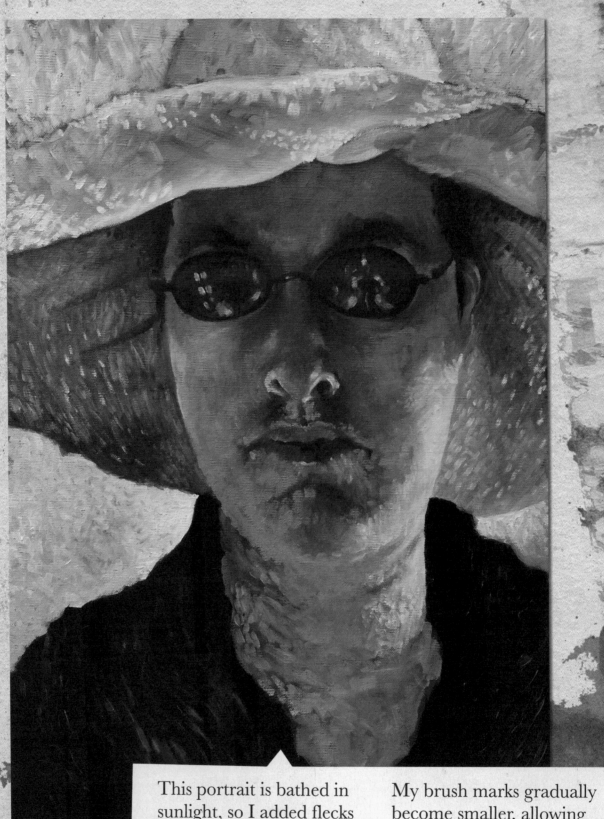

This portrait is bathed in sunlight, so I added flecks of light coming through the hat brim and little touches of highlights throughout.

My brush marks gradually become smaller, allowing the base colours to show through.

CHAPTER 4

LIGHT AND SHADE

Tone is created by the way light falls on a 3D subject. Highlights are where the tone is lightest and the light is strongest. The areas which are darkest are shadows. It is this range of tones from light to dark that can help make your subject look three dimensional.

Adding tone to a drawing helps to create the illusion of form on a 2D surface. The directional line of the marks you make can also help to emphasise the form of your subject. Dramatic artwork can be created by the use of strong contrasts between the lightest and darkest tones.

Texture expresses the surface quality of your subject and gives an indication of how it would feel. Drawings can have different kinds of texture: a visual texture is when the feel of the surface has been created by the use of the medium, whereas actual texture is where the medium itself has texture or has been used to create a physical texture.

NEGATIVE SPACE

This piece of artwork is reliant on negative space to suggest a scene populated by a crowd of figures. This technique is a very direct way of making a picture that is striking and visually bold.

Materials:

- Inkjet paper (265 gsm)
- Pastels: white, grey, black
- Brush
- Black ink

Begin by creating a black ground on your paper. Use ink and a big brush to paint a black shape, as big or small as you want.

If you want to use a photograph for some help, try to find an image that is *contra jour*, or taken facing directly into the light. This will obscure all the detail and leave basic shapes, which is what you are looking for. Use a white pastel to draw in the negative space.

ARTIST'S TIP:

If you want to draw the negative space of a crowd from imagination, you must focus on these areas alone, not on the people.

Using your finger or a paper stub, smudge the pastel to make more distant figures into shades of grey. The closest figures will be the darkest. Add a few white lines to add definition to some of the figures.

Finally, add some touches of colour to the figures and strengthen some of the whites to give the impression of light shining through the figures.

STREET SCENE IN OILS

This street painting of people is backlit by the sunlight directly behind them. This effect is called *contre-jour* – French for 'against the light'. It creates interesting halos of colour and lovely shadows, and makes a good subject to paint.

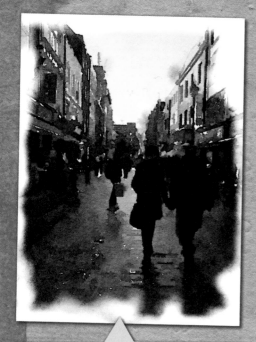

Start with some sketches. I like to work from very basic photographs taken on my phone. I then pare them down further in my watercolour sketches.

Once I have decided on a composition that I like, I grid the canvas to enlarge my sketch.

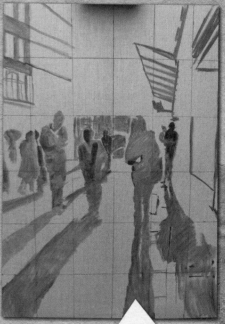

My initial drawing is done with a mixture of burnt sienna and French ultramarine diluted with turpentine.

56

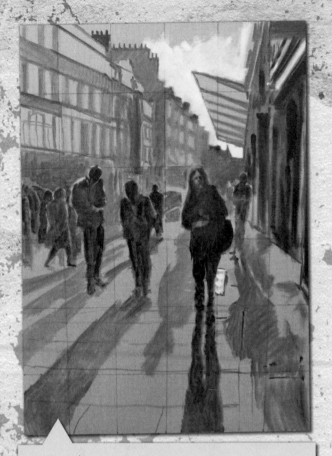

I block in the dark shapes to gradually build up the picture.

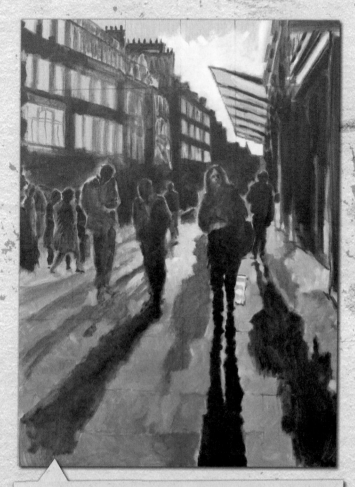

Then I block in the areas with the lightest tones.

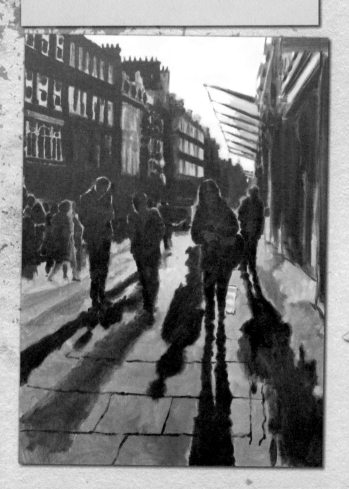

Continue adding darker tones. Once the large areas are dark enough, begin to bring in more colour.

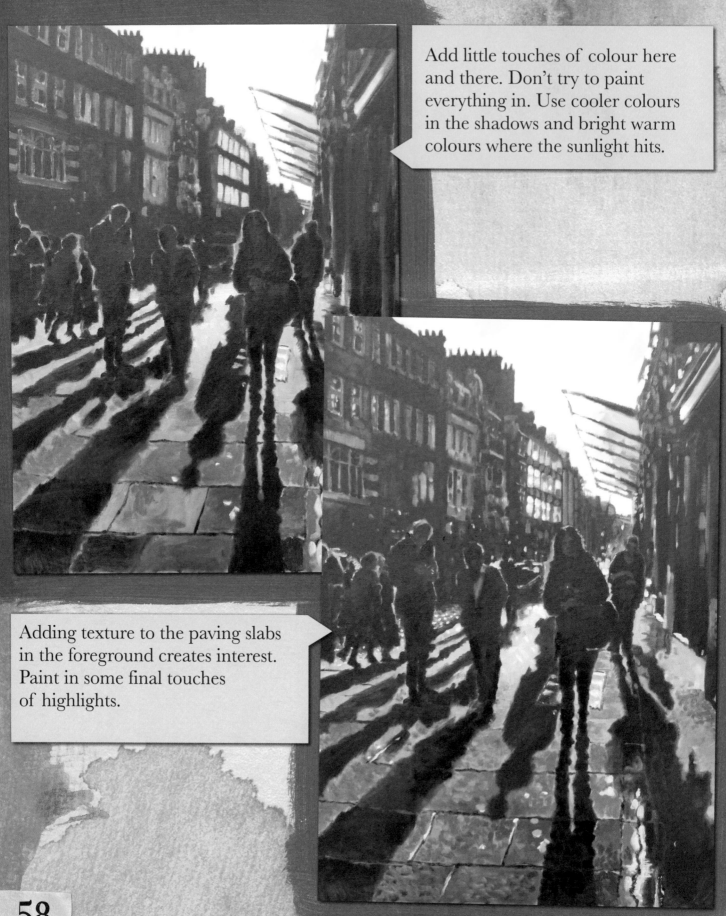

Add little touches of colour here and there. Don't try to paint everything in. Use cooler colours in the shadows and bright warm colours where the sunlight hits.

Adding texture to the paving slabs in the foreground creates interest. Paint in some final touches of highlights.

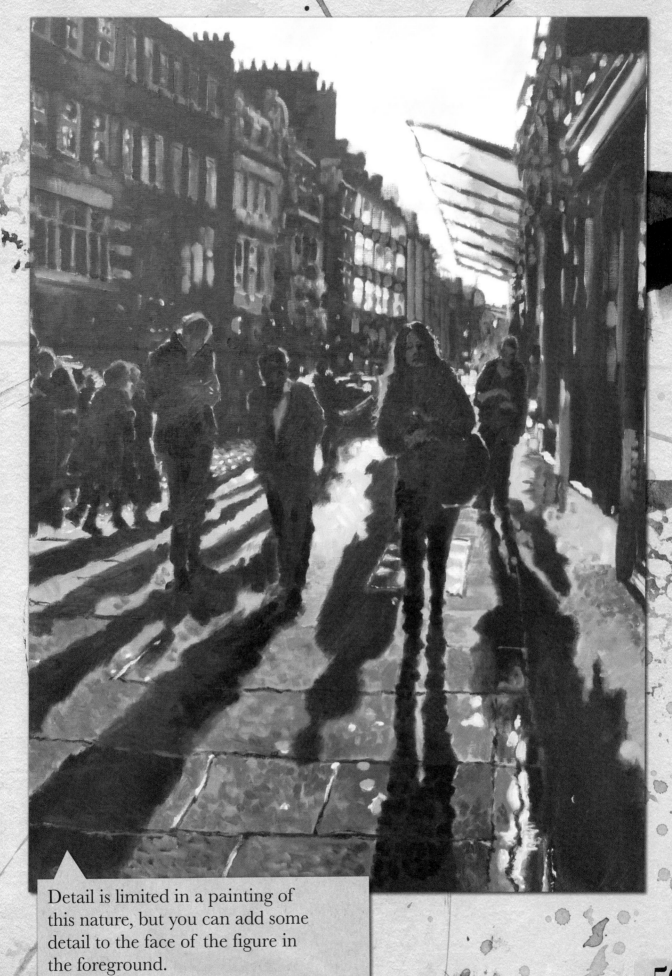

Detail is limited in a painting of this nature, but you can add some detail to the face of the figure in the foreground.

CAFE CULTURE

Using tinted paper cuts down your decision making. You already have your mid tone, so you can concentrate fully on getting the lightest and darkest tones just right!

Materials:

- Pastel paper (170gsm)
- White and black pastel pencils
- Putty rubber
- Paper torchon

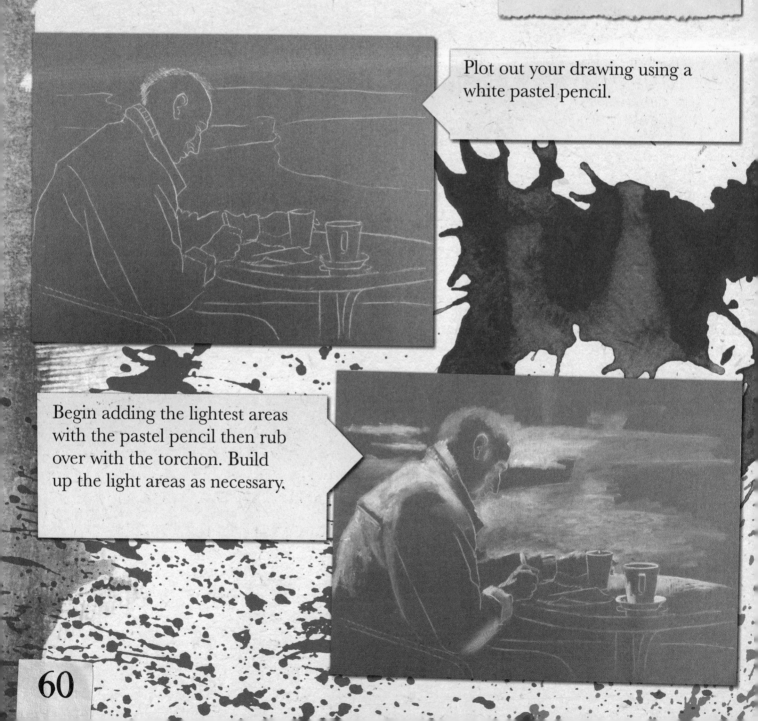

Plot out your drawing using a white pastel pencil.

Begin adding the lightest areas with the pastel pencil then rub over with the torchon. Build up the light areas as necessary.

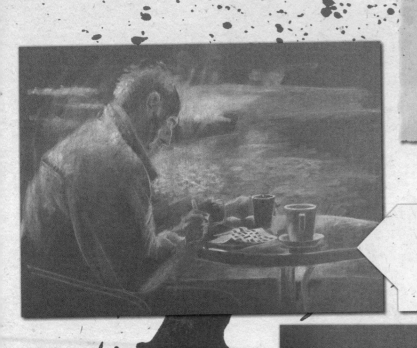

ARTIST'S TIP:

It is worth buying tinted paper that has been specially developed for working with pastels.

Add some more details to the items on the table top. Heighten areas of light by layering.

Soften some of the edges using the torchon or putty rubber.

Start adding some detail using the black pastel pencil. Use a light touch at this stage and build up the dark tones gradually.

CAFE CULTURE PART 2

Rub the blacks into the paper and build up layers to create the blackest blacks.

Check your drawing regularly. It's a good tip to look at it in a mirror. You will see clearly which areas need more work or simply look wrong because this view gives you a different perspective.

Add some final highlights of white to add zing to your drawing. Job done!

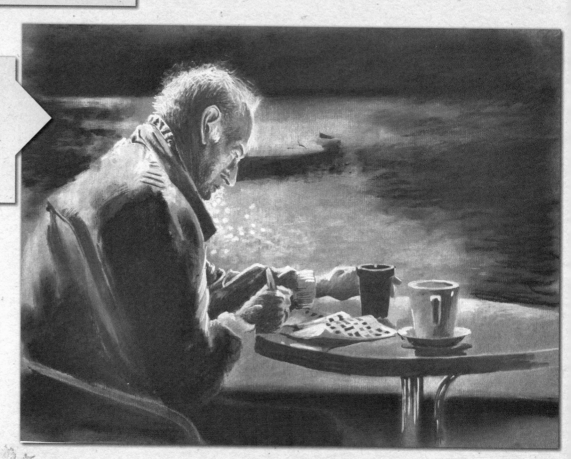

CHAPTER 5

HOW LONG DO YOU HAVE?

How you approach a subject can depend entirely on how much time you have to spend on artwork. You may only have ten minutes or perhaps three hours, yet both results can be equally as exciting.

A quick drawing done in an expressive style can often successfully capture the energy and vibrancy of your subject. With practice you will start to recognise the most important elements to capture.

When you have more time, you can study your subject carefully to consider how best to make marks that will capture the elements of your composition. You will also have time to work on smaller details.

QUICK INK SKETCHES

This is a very quick sketch of someone cooking. I used ink, water and a brush only. Often when people are busy they move around a lot. Capturing the essence of an activity or a person's posture takes quite a lot of practice. Like everything else, practice gives you confidence. It may not make things perfect but it will improve them. So, how do you start when you don't have much confidence? Try making quick ink and wash sketches from photographs but use a brush and water to keep your sketches loose. Experiment this way for a while, then have a go from life.

Materials:

- Smooth, hot pressed paper (300gsm)
- Watercolour brush (round)
- Black drawing ink
- Water

Dip the brush in water again and lightly paint in the shape of the arm. Try to paint shapes rather than outlines and don't worry too much about getting everything just right. This is just practice!

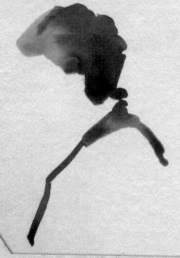

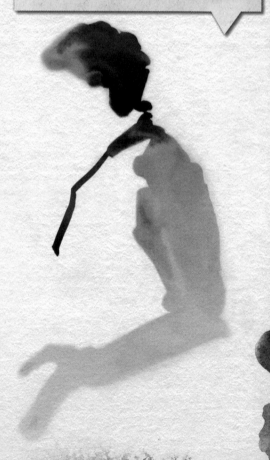

Dip your brush into water then into the ink so that it's less black. I started with the shape of the hair, the top of the shoulders and the front of the apron.

64

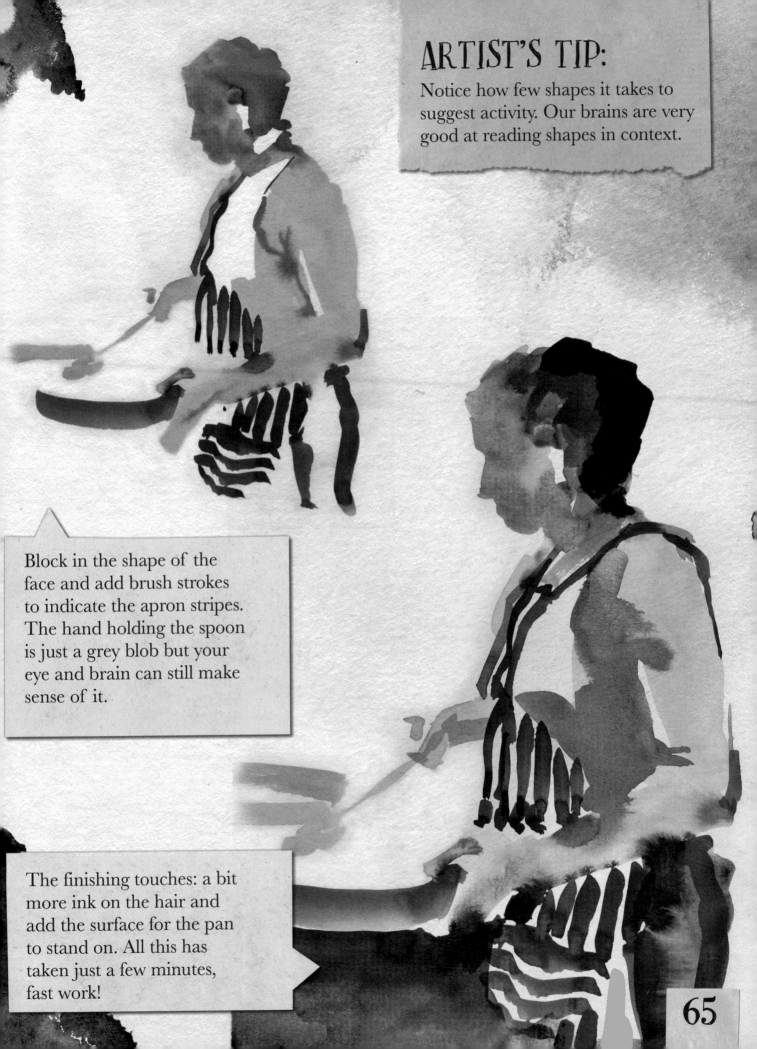

ARTIST'S TIP:
Notice how few shapes it takes to suggest activity. Our brains are very good at reading shapes in context.

Block in the shape of the face and add brush strokes to indicate the apron stripes. The hand holding the spoon is just a grey blob but your eye and brain can still make sense of it.

The finishing touches: a bit more ink on the hair and add the surface for the pan to stand on. All this has taken just a few minutes, fast work!

65

'SNATCHED' SKETCHES

This is a quick 20 minute ink sketch using a contour drawing style with a dip pen. You could do this from life, but in all honesty, trying to use a dip pen and a pot of ink on a crowded tube train is quite possibly madness! You can work from a photograph that you have taken whilst travelling, or my preferred option is to do quick, on-the-spot pencil or marker drawings in a little sketchbook. People seem far less bothered by someone doodling and it's less intrusive than trying to photograph them. This is a bigger sketch worked up from a small scribbly drawing.

Start with the figure in the centre. Try to catch the shape of his face and hair. Don't worry if he moves as this style of drawing almost welcomes second thoughts – it is like thinking aloud on paper.

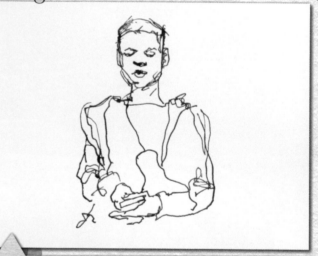

Scribble your way around the rest of him. Think about how his jacket might feel as well as how it looks. He has one earphone in and is looking at a phone in his hand. Being aware of all this as you draw will help you.

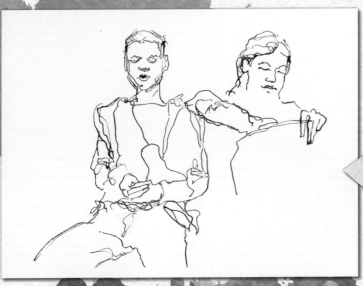

ARTIST'S TIP:

Talk to yourself as you are drawing to feed in the details that your eye is constantly taking in.

Once you've captured his posture, move on to the girl beside him. As she rummages in a big bag, her hand catches my attention so I quickly draw it.

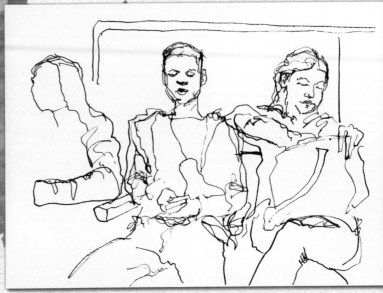

The girl's posture is entirely different. With her legs crossed, they become foreshortened – that is, they appear shorter because of their angle. This comes down to perspective: it is a useful skill to develop for drawing in general.

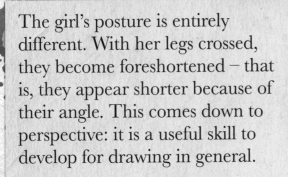

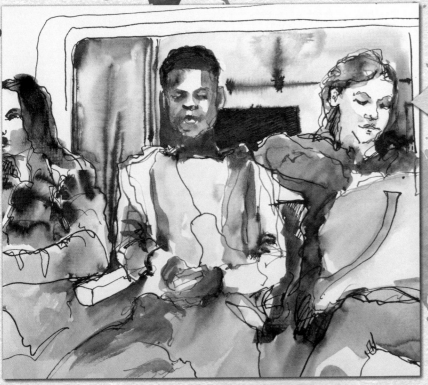

Add the third figure and finish off with some tonal shading. The quickest way is to dip your brush in water and wet some of your existing ink lines.

WATERCOLOUR WASH

This quick watercolour sketch took ten minutes at most. I used only two colours and a big jar of water, and I taped the paper down first to stop it moving.

Materials:

- Cold pressed watercolour paper (300gsm)
- Sable brush(es)
- Watercolours: burnt umber, indigo

Mix both colours into a nice puddle of paint. Hold your brush by its tip (as if you were about to start conducting) and dip it into water first, then into your paint. Start with her hair.

Now loosely paint in the face shape, the chin and neck. This is a bit like doing a blind contour drawing with paint.

Apply the paint loosely. Don't worry about splodges or splashes as these add vitality to the image.

Doodle in the striped pattern of the jumper. Keep these brush marks loose and fluid, too. The stripes are not rigid.

Now look carefully at the facial features. Try to reduce them down to shapes made by shadows: the eye sockets, under the nose and the top lip. This lightning-fast sketch is about minimalism and a light touch!

69

'STILL LIFE' IN PASTELS

Someone's fallen asleep on the sofa so grab the opportunity to make a very quick pastel sketch. I keep a sketchbook with black inked-up pages just for pastel or gouache sketching. It makes a change to work on black paper sometimes.

Materials:

- Cheap sketchbook
- A large brush (for inking)
- Black ink (base coat)
- A basic set of pastel pencils

If you have no black paper handy, quickly ink up some paper and let it dry.

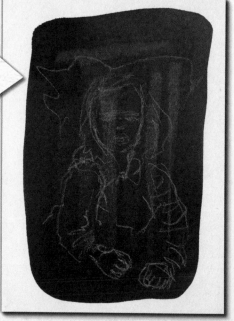

Start with a quick loose pencil drawing in yellow ochre. Keep your eye on your subject and less on your paper. Keep judging the relative sizes of everything as you draw.

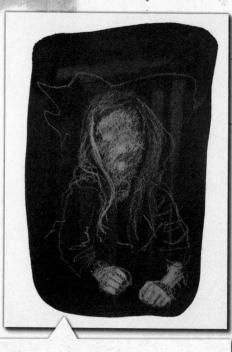

Loosely block in the hands and face – make the black paper work for you. Use the pastel pencil more in areas you want to be much lighter so that less of the black shows through.

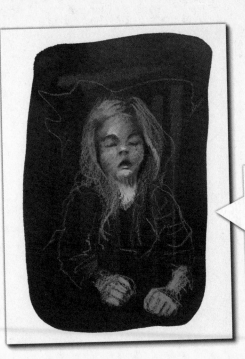

Start adding colour. Use dark browns or reds for shadow areas, and lighter yellows or white for highlights.

Block in more areas of colour, again making the most of the black paper. Notice how well the colours show up on top of the black. You will find it really easy to blend pastel pencil colours.

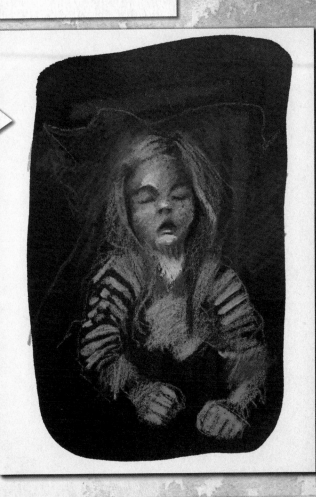

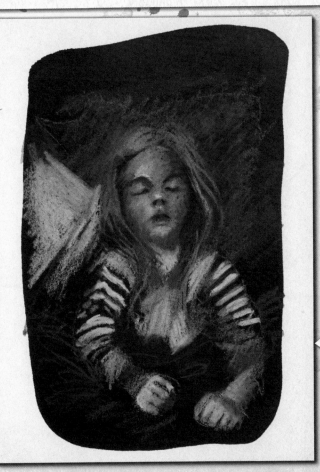

Last details: add white highlights to the hands, dark reds for the shadows, and a little colour change on the stripy top. A few little squiggles to indicate the blanket and that's it done!

WATERCOLOUR PASTEL PARTY

Drawing children is difficult as they wiggle about rather a lot. Take four children, feed them party food and the task gets even worse! So snap away and then work from photographs. Don't use the best image – it's almost easier to use a slightly unfocused, smaller photo as you won't be bogged down with excess detail. This is how to keep it loose and lively.

Materials:
- Mounting board
- A selection of brushes
- Watercolours
- Pastels: white, mid and light blue, purple, yellow ochre, dark red

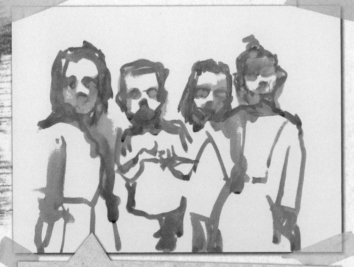

I start with a very rough drawing in watercolour. Keep your brush marks loose and watery. Try to capture the general stance of the children and block in areas of shadow. Half close your eyes to see shape and tone only.

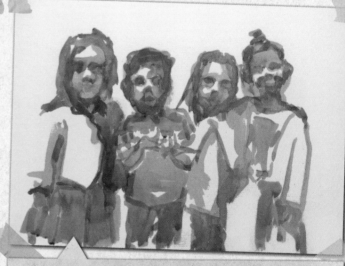

Add a few really loose pale washes of colour here and there. Add washes to the faces to redefine cheek shadows, eye sockets and the shadow under the nose.

Once dry, add some very rough details like stripes, patterns and skirt gathers. It's a mixture of lightly drawing with the paint and loose washes of colour. If you need to add colour and then detail, allow the paint to dry between layers.

Wash over some areas, like the boy's shirt. This softens the detail and pulls it all together. Add detail here and there as required, and perhaps some light touches of definition to the faces.

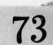

73

Once dry, use your pastels to redefine some of the shapes. Look at the spaces between each child, add some stronger colour to the clothes and use the white pastel pencil to draw on top of the watercolour.

Add some final touches using a pastel pencil. Draw the children's features using simple expressive marks. Keep all detail to a minimum. Avoid outlines as you are attempting to capture a moment in time for four little party people.

CHAPTER 6

CREATIVE RISKS

Taking creative risks with your approach to artwork can help you to explore new styles and ideas whilst still improving your overall skills. Sketchbooks don't have to be filled with 'perfect drawings'. Try some experimental exercises that may help you to 'see' in new ways by taking you out of your comfort zone.

You can try to break free of making predictable marks by forcing yourself not to look at the paper while you draw, only at your subject. Or, try not lifting your pen or pencil off the paper at all whilst completing your sketch. Perhaps you could even cover your paper in graphite and erase parts of the image to create a negative.

Experiment and take creative risks to develop your range of marks and your observational skills.

BLIND CONTOUR DRAWING

Blind contour drawing is a great practice exercise. It tones up your observation skills, gets rid of your inhibitions and makes your drawing more fluid and expressive. Honestly! The point to this exercise is the process, not the end result!

Materials:
- Sketchbook
- 3B pencil

You will be drawing 'blind' in one continuous line. Your eyes must be glued to your subject as you draw. Once you put pencil to paper you don't lift it off again or glance at your drawing. As your eye moves around your subject, your drawing hand will describe what you are seeing.

People do move a lot while you are drawing them. It can be helpful to think yourself into the position they are in. A café is a good place to observe people. You will begin to recognise that people often move, but in a limited range of poses.

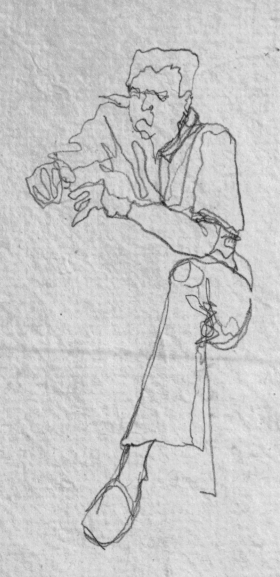

ARTIST'S TIP:

If you can't trust yourself not to sneak a look at your drawing then try to obscure it from view – under the table top, perhaps?

As your eyes move around your subject, your pencil line should follow. They will both move independently but in unison. Don't lift your pencil or you will lose your place in the drawing. If you want to move to another area, then lessen the pressure on the pencil in transit but keep the speed of your hand and eye motion the same.

Keep your line free-flowing throughout. Allow your pencil line to scribble and turn to follow a change of direction, like the turn of his knee.

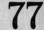

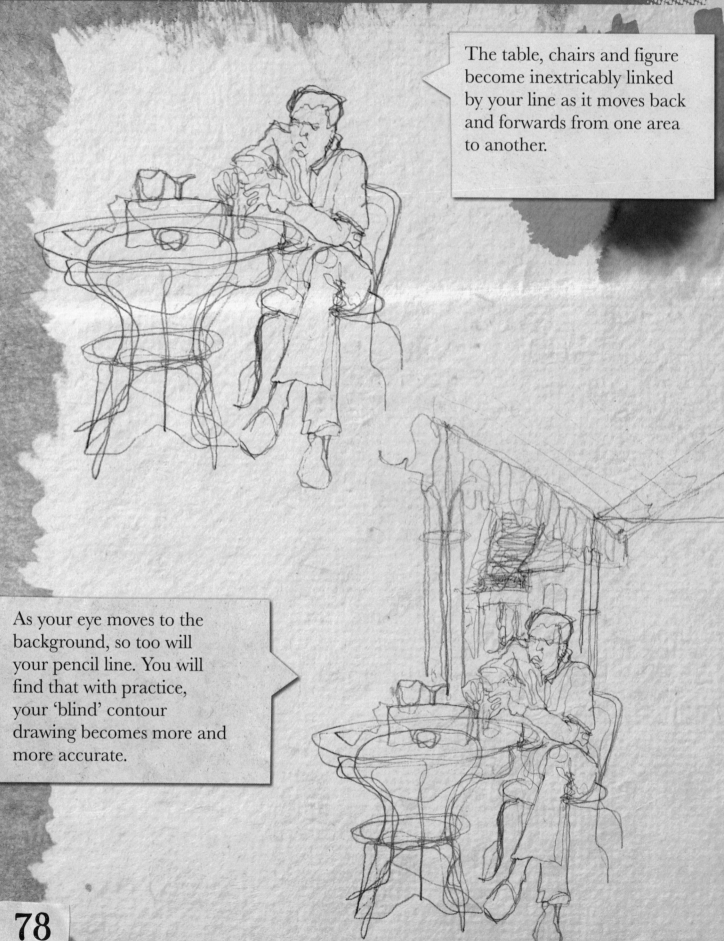

The table, chairs and figure become inextricably linked by your line as it moves back and forwards from one area to another.

As your eye moves to the background, so too will your pencil line. You will find that with practice, your 'blind' contour drawing becomes more and more accurate.

The end result may be very
wobbly, but notice how
well observed some of the
details are. This exercise
will help you to recognise
what aspects you find most
important in what you
are observing.

Adding figures to your sketches gives a sense of scale, and adds human interest. Sometimes you might add figures out of necessity, just because there are people in the place that interests you. Again, this is a matter of confidence, so just practise until you are comfortable. Here is a very easy way to paint simple watercolour figures. It's like doodling!

Materials:

- Cold pressed paper (300gsm)
- Brushes
- Watercolours: burnt sienna and French ultramarine

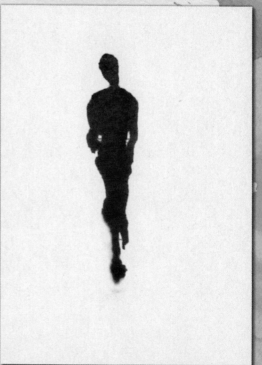

First, mix up a puddle of burnt sienna and another of french ultramarine. Dip your brush into the burnt sienna and make a long egg-shaped blob. Then paint a shape like a number 7 for the shoulders and torso.

Now dip your brush into water and gently mop off the excess on a bit of kitchen towel or clean rag. Wiggle the damp brush downwards, letting it spread out at the hips and narrow towards the ankles. Add the arms in the same way.

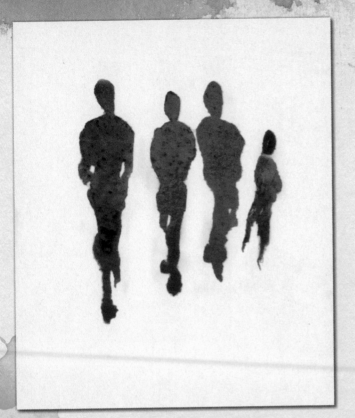

ARTIST'S TIP:

Once you get started, don't stop. Fill your page with figures – you'll soon get the hang of this.

As someone walks towards you, one leg will be in front of the other so they become separate shapes. Add a touch of blue into the damp paint and let it spread to indicate some clothing. Try some more shapes in different positions to create a variety of figures.

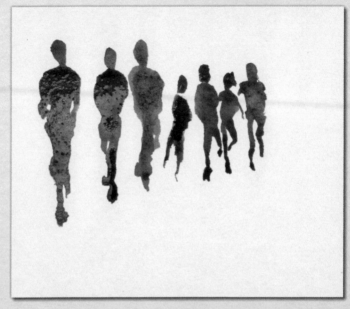

Remember that these doodles are just practice ones, so don't be afraid of getting it wrong. This is exactly how you will build up your confidence.

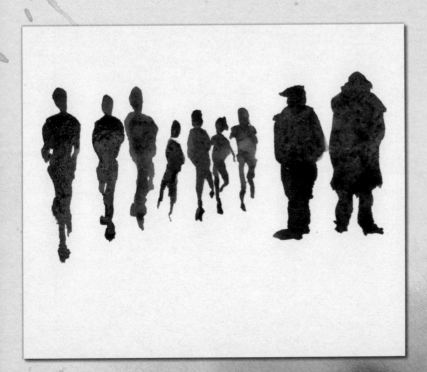

Now that you've started it gets easier, doesn't it? Once you have filled a few pages, try adding bulkier shapes – imagine raincoats, hats, big people, little people.

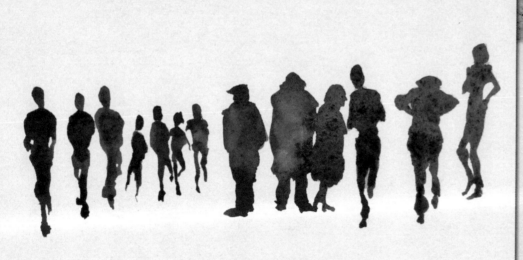

Paint people walking away, people with their arms crossed, hands on hips, thinking, bending down – there is no end to the possibilities…

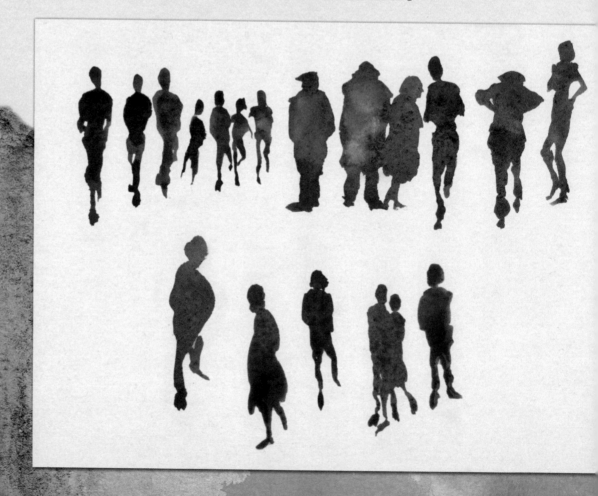

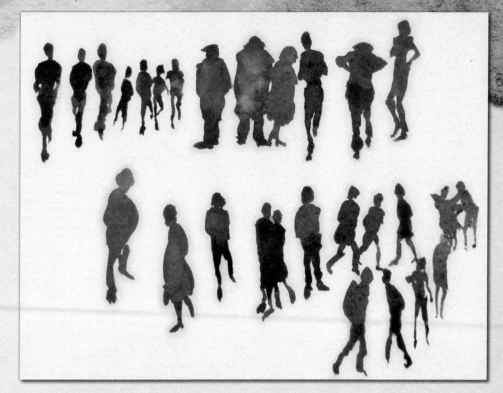

… It's all there in your imagination – your visual dictionary that you have been building up since you were born. What you are doing now is practising using it and becoming fluent in conjuring up your own imagery!

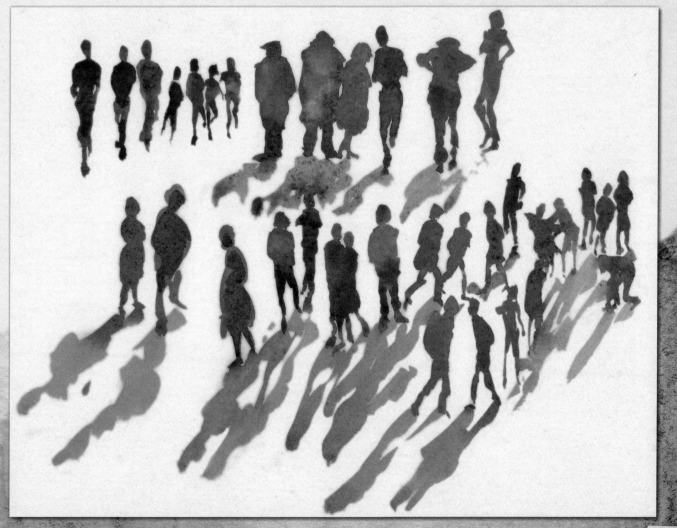

IMAGINATION CROWD

Drawing, painting and sketching is enjoyable whenever you have some free time. But don't think that in order to take your art seriously you have to limit yourself to drawing from life. You can use your imagination for inspiration. This project is like doodling. It's fun, it's easy and you will be honing a few skills along the way … it's a win, win situation!

Lightly pencil in the first figure with a simple egg-shaped head, a couple of little ears, a tuft of hair, two eye dots and lines for the nose and mouth.

Add some more figures standing around and behind him. Make each figure a variation of the first one: thin, fat, old or young.

Now fill in the space with lots of egg shapes, some fat and some long. I put one head in profile for fun – just to have one of my crowd not listening.

ARTIST'S TIP:

This style is fun, but it can feel like 'knitting' a drawing. It's probably best to do it in stages or it may drive you mad!

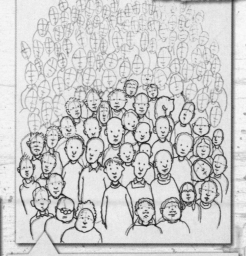

Lightly pencil in some guide lines for facial features. Let the crowd and the details peter out towards the back.

Start inking in the lines with a mapping pen. Add hair styles, beards and moustaches as you go. Let your imagination soar.

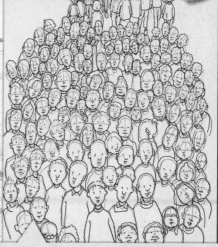

Keep going. This is a test of your artistic endurance which is often the key to any work – the ability to keep on going to the end! People often throw their hands up in the air and say "I can't draw". Yes you can…you just need to try a bit harder.

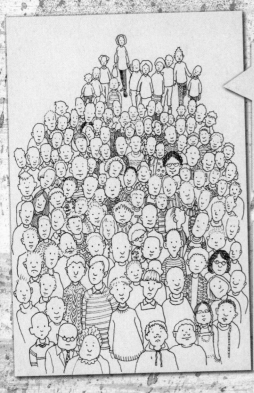

Once all the lines are inked in, gently rub out the pencil lines. Then start to add patterns, hats, glasses – anything that you want.

Now start painting. Try to do one colour at a time, so make all the faces pink, red, brown or yellow. Then do the hair.

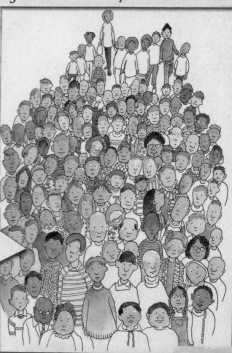

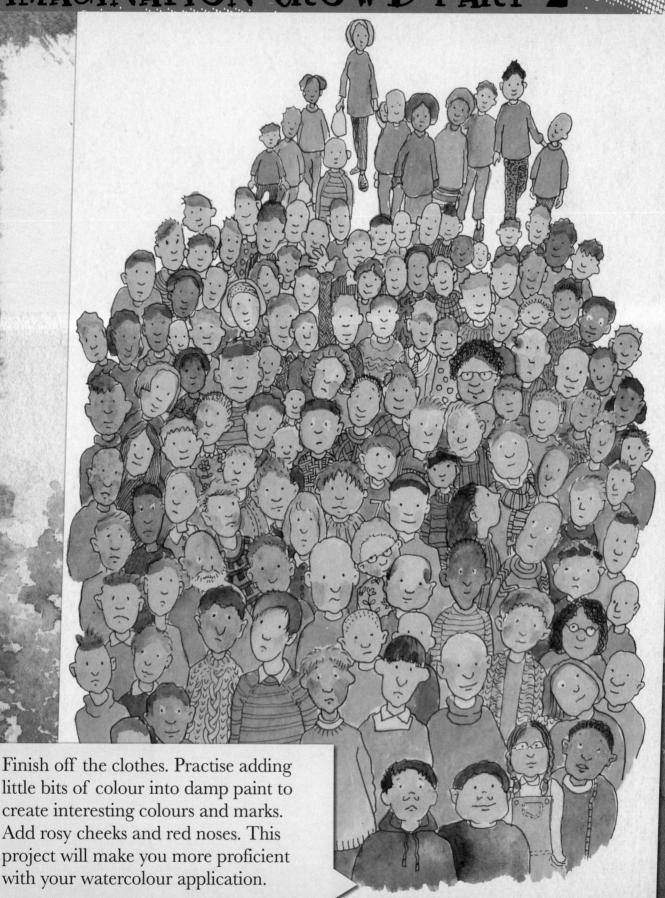

Finish off the clothes. Practise adding little bits of colour into damp paint to create interesting colours and marks. Add rosy cheeks and red noses. This project will make you more proficient with your watercolour application.

86

CHAPTER 7

STYLES AND TECHNIQUES

The human figure has been portrayed in many different ways throughout the history of art. Find inspiration in the art section of libraries or bookshops. Look at the many different styles and techniques that have been used for portraiture and figurative subjects. Find the artists and styles that have most appeal for you. Recognise what you are responding to – is it precision, realism, expressionism, or perhaps fantasy? Or you may simply be excited by the use of a new medium? Whatever the appeal is, just have a go at emulating and practising it to see where it takes you next.

BOY WITH GUITAR

This loose watercolour sketch shows that, with layers of washes, you can suggest form and texture quite easily without painting every single detail.

Begin with a light pencil sketch, marking out key points of your subject. This really loose guide will help you to establish the initial watercolour washes.

Start with the head. Use a brush loaded with burnt sienna to draw and then block in shadowed areas with watery brush strokes. Let the paint spread and do the work for you.

88

ARTIST'S TIP:

Accidental colour mixes can be very effective. Don't worry about colour choices – it is the tone of the colour that is important.

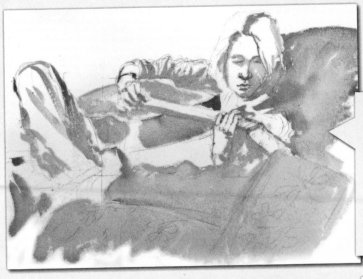

Continue drawing and painting. I have drawn some areas, like his hands, in more detail, while other parts are pure washes. Then I dropped in some olive green colour for the chair and let the washes run.

Let these first washes dry (you can speed up this process with a hair dryer). Letting watercolour dry naturally creates a slightly different result from the hair drying method – experiment to see what you prefer. Add some more washes: use a light wash of raw umber on the face, hands and guitar, and alizarin crimson for his shirt.

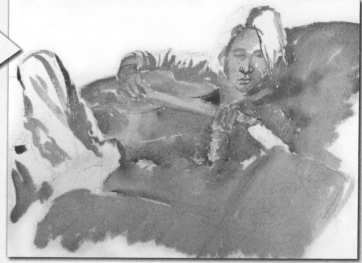

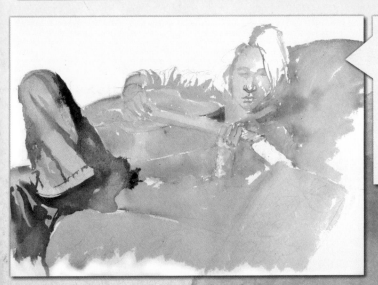

Draw and paint in some indigo for his jeans. Notice how washes lighten as they dry. You will get used to these tonal changes the more you use watercolours.

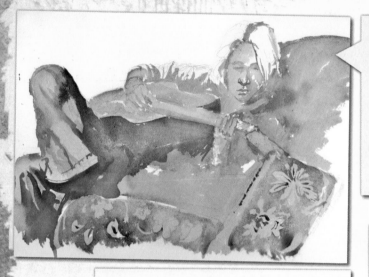

I mixed a muddy green colour by adding a touch of indigo to the olive green to draw patterns on the chair. I created the flowery pattern by painting in the background area only.

Allow to dry. Now add some detail to the 'throw' using olive green paint on top of the olive green wash.

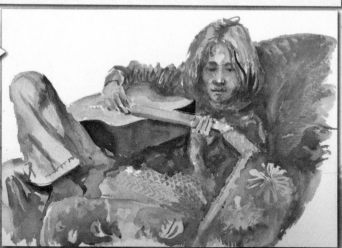

Add more detail to the face and hair. Layering washes enables you to build up the dark areas and change any shapes. Notice how the shape of his face has changed with a few lines and washes.

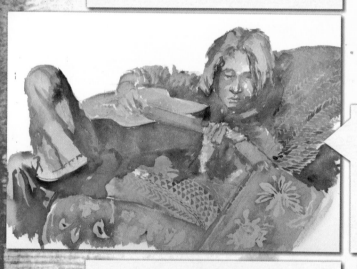

Add a few dark touches to the guitar to define its shape. Strengthen the colour of his shirt.

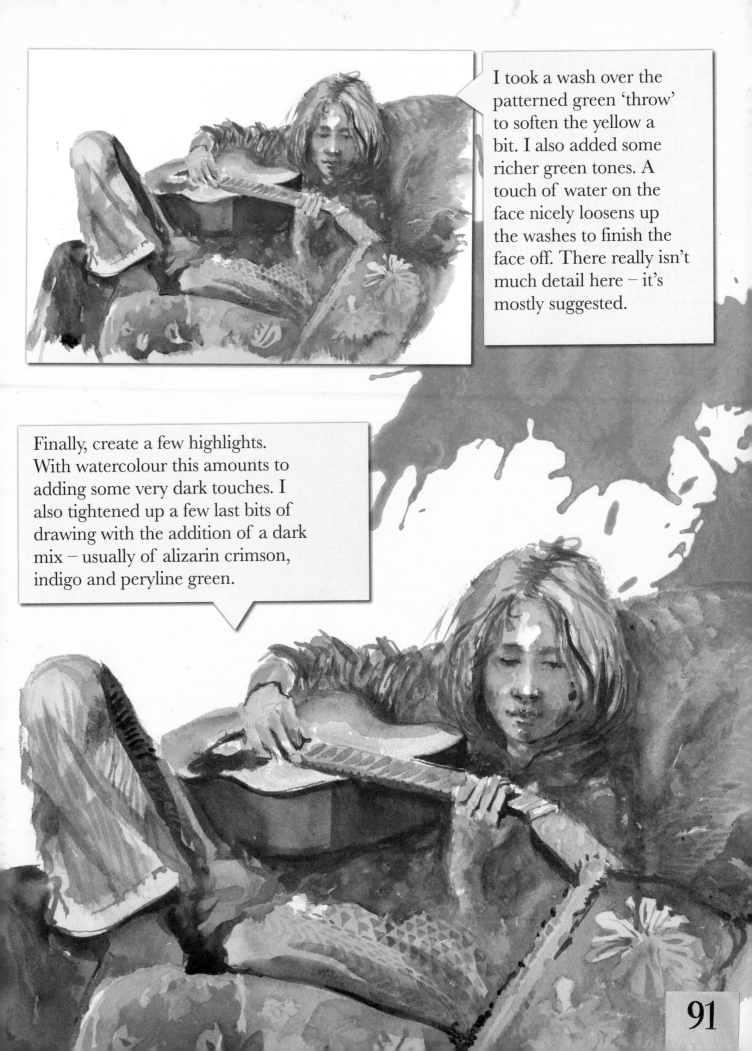

I took a wash over the patterned green 'throw' to soften the yellow a bit. I also added some richer green tones. A touch of water on the face nicely loosens up the washes to finish the face off. There really isn't much detail here – it's mostly suggested.

Finally, create a few highlights. With watercolour this amounts to adding some very dark touches. I also tightened up a few last bits of drawing with the addition of a dark mix – usually of alizarin crimson, indigo and peryline green.

91

BLACK TIGHTS

This is a pastel sketch showing both negative as well as positive space. Clothes can often make wonderful shapes, especially black ones, like the tights worn by my subject.

Materials:
- Mounting board
- A large brush for washes
- Brown ink
- Black pastel pencils
- Pastels: burnt sienna, dark grey, yellow ochre, burnt umber, cadmium red, cobalt blue, sandstone, white, black

Start by making a coloured ground to work on. I used a brown ink wash to create the base. Leave to dry.

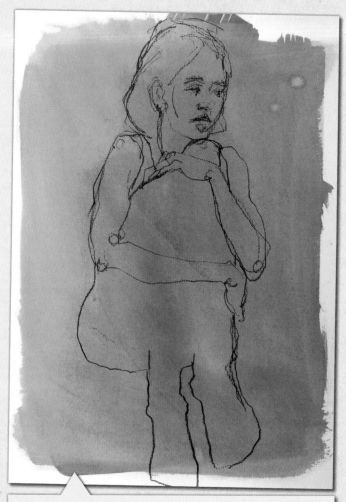

Use the pastel pencil to draw a very loose, linear sketch with no shading. The line simply wanders around the outlined shape of the girl's legs.

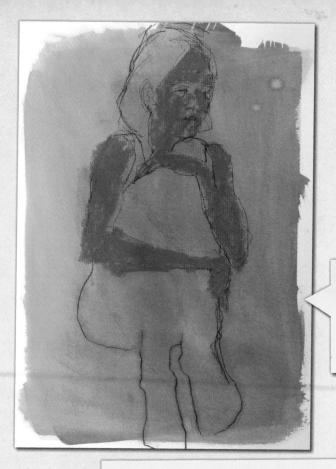

ARTIST'S TIP:
Look at the work of John Singer Sargent to see his use of negative and positive shapes.

I roughly blocked in the skin colour of the arms and face using quite a strong colour: burnt sienna.

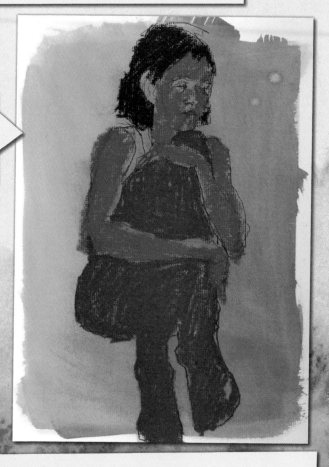

Then I blocked in the hair with a dark brown, and the tights with a cool mid grey.

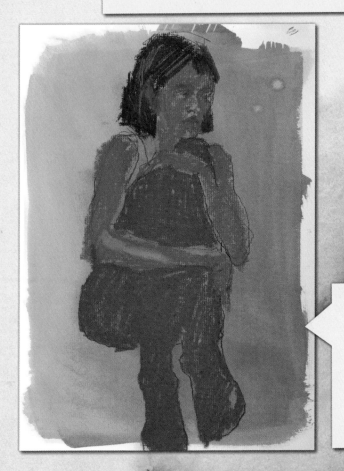

Add touches of dark pink to the shadowed parts of the face and to the elbows and fingers. Pick out some highlights on the hair with yellow ochre.

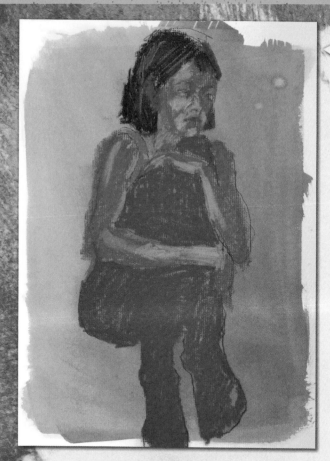

Add some light flesh colour to the face and arms to indicate the light source. Add a touch of bright blue to her vest.

Blend these colours together with your finger or a paper torchon. Use the sharp edge of a dark pastel to indicate the eyes and to redefine the edge of her arm and knee.

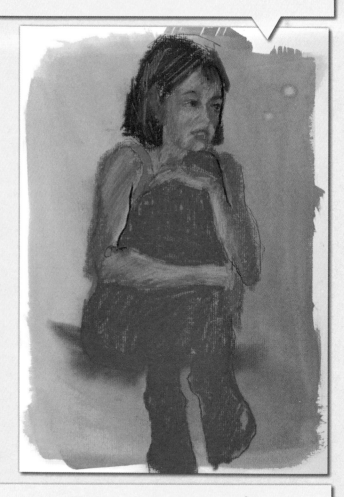

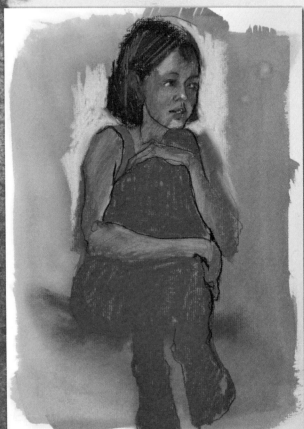

Do a bit more blending and add some more line definition with the pastel pencil, but keep the line loose. Add white pastel to the negative space around the figure to define her shape further.

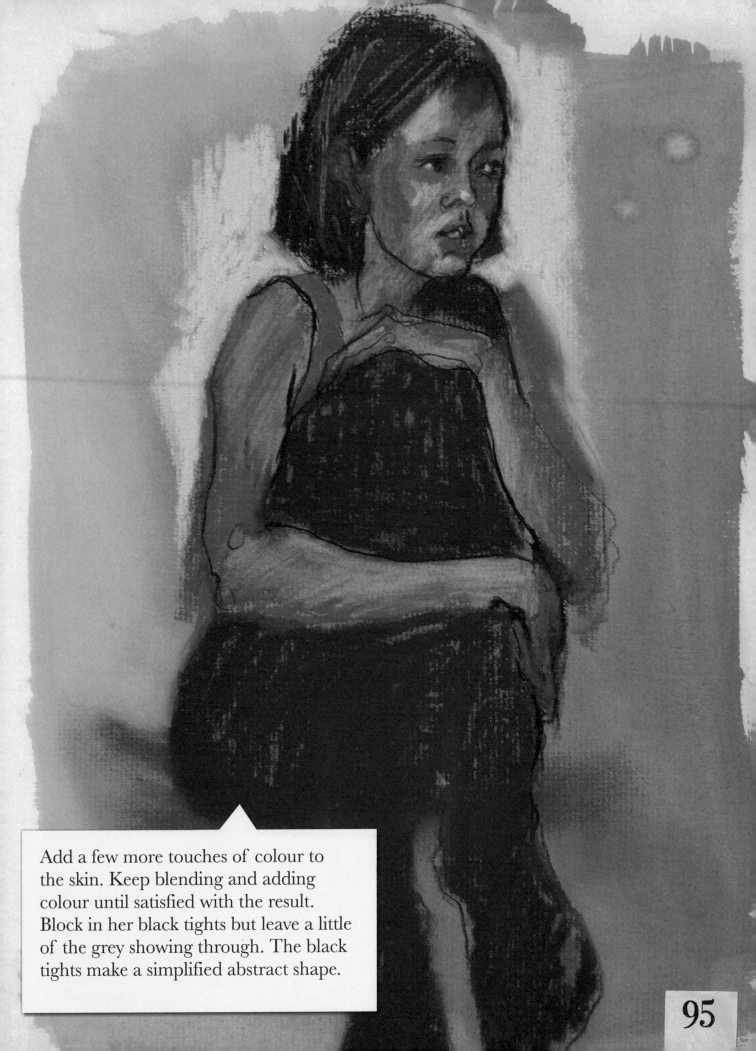

Add a few more touches of colour to the skin. Keep blending and adding colour until satisfied with the result. Block in her black tights but leave a little of the grey showing through. The black tights make a simplified abstract shape.

TABLET LIFE

Drawing with one of the drawing/painting apps now available is not only great fun but also very useful. These days most of us have a phone that we generally carry with us. So use it to make quick sketches to amuse yourself on the station platform, sitting at the back of a bus, or in a doctor's waiting room – anywhere, in fact. Best of all, you can remain invisible, as most people just won't notice that you are drawing!

Materials:
- A tablet device
- One or more drawing apps. I use several: Procreate, Brushes Redux, Art Set, Pen & Ink and Omni Sketch
- A stylus (or use your finger)

I begin with a background colour. This will help me to judge the lights and the darks that I plan to add.

First, I roughly scribble in a dark shape for the chair. Then I make a new layer, and start to block in the shape of the subject's head.

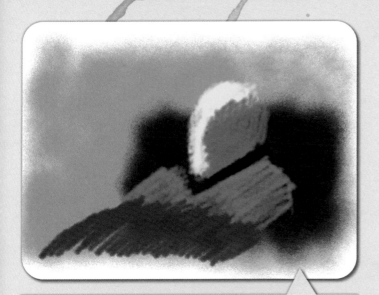

Now I block in a very approximate tone for the side of his head in shadow and also his shoulders and blanket. All these colours will be worked into again, so think of them purely as base colours at this stage.

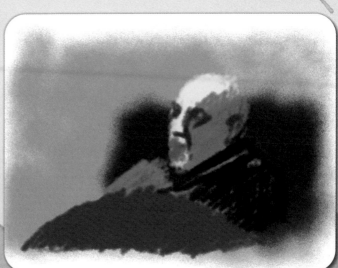

I half close my eyes to draw in some additional areas of dark tone.

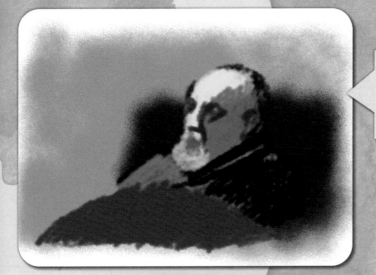

Then I go back to the first layer and draw a dark outline around the head. This means that I am now working under the colours created on the second layer.

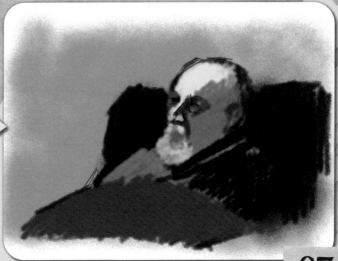

97

TABLET LIFE PART 2

At this stage I have made a few colour changes to the head and I have started to add some small linear details.

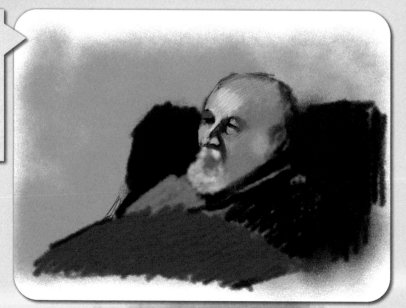

Now I go back to the top layer, and using a thinner 'brush', I start putting in a few more details. Try cross-hatching with closely-related colours to build up texture.

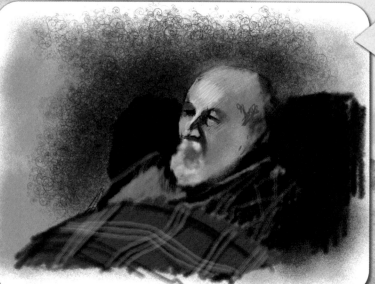

When drawing the blanket pattern, draw in the dark lines first and add pale lines on top.

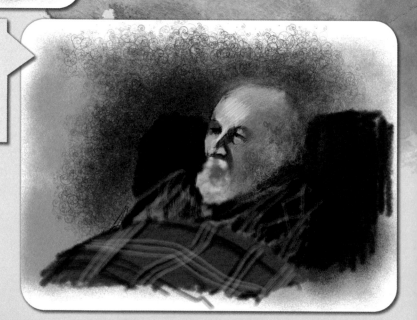

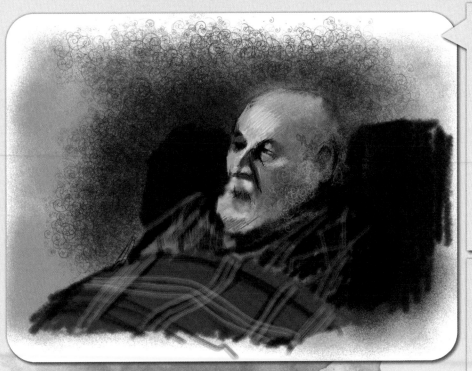

This is yet another fresh layer. Choose a brush with a different texture to soften up some of the lines. If you try out different textured brushes on another layer again, you can experiment without ruining any of your existing work.

I keep adding little touches here and there, until I am happy with the end result. A few tiny highlights of pure white add that final zing!

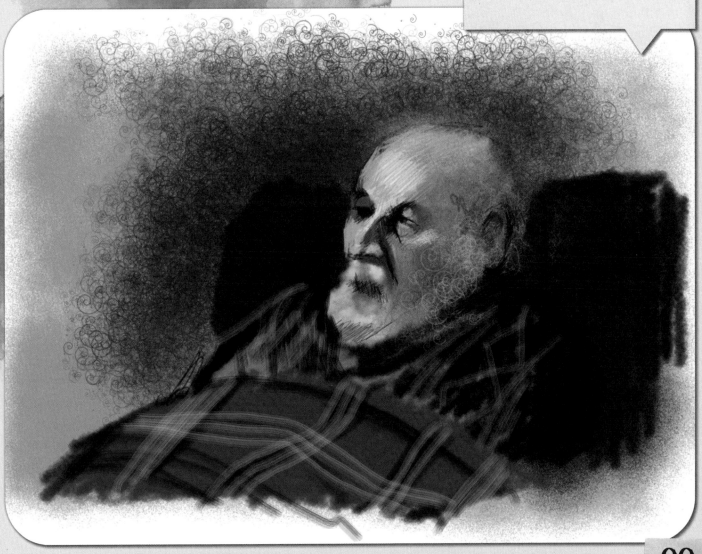

MINIATURES: SLEEPING BABY

Miniatures used to be painted on ivory or vellum, which is a very fine calf skin. Vellum was used by monks for illuminated manuscripts and lasts for hundreds of years. Ivory can no longer be used but mammoth tusks, found in the permafrost of Siberia, is available in very fine sheets. It makes a fascinating alternative. There is also a man-made plastic surface called Ivorine. Paint sits on the surface of these materials so you can carefully build up with tiny cross-hatching brush strokes. Or, just use a very smooth HP watercolour paper.

Materials:

- Smooth pressed watercolour paper
- 3H pencil
- Very fine brushes
- Watercolours

Start with a simple pencil drawing. Make sure the pencil has a sharp point and draw with a very light touch.

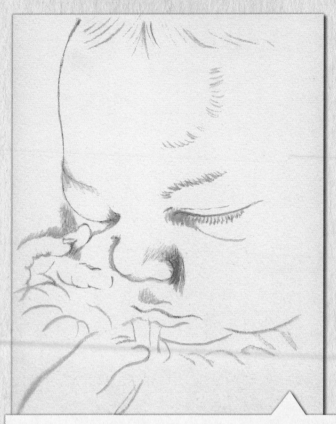

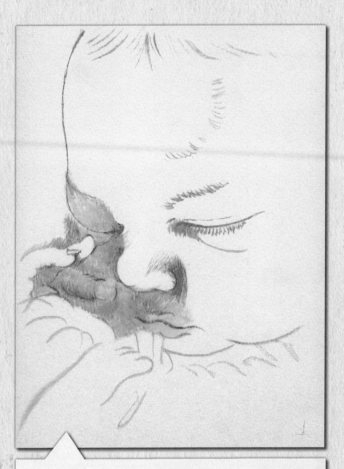

Lightly follow your pencil lines with a burnt sienna mix. Use a delicate touch – no strong or thick paint. Areas of paint are built up with careful cross-hatching with an almost dry brush.

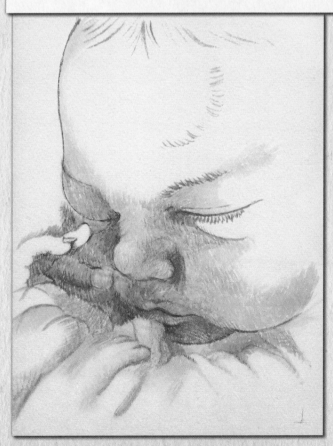

Vary the colour used for the underpainting, as these colours will affect the colours that go on top.

Add some washes to the background. Remember to make sure each layer is dry before you paint on top of it.

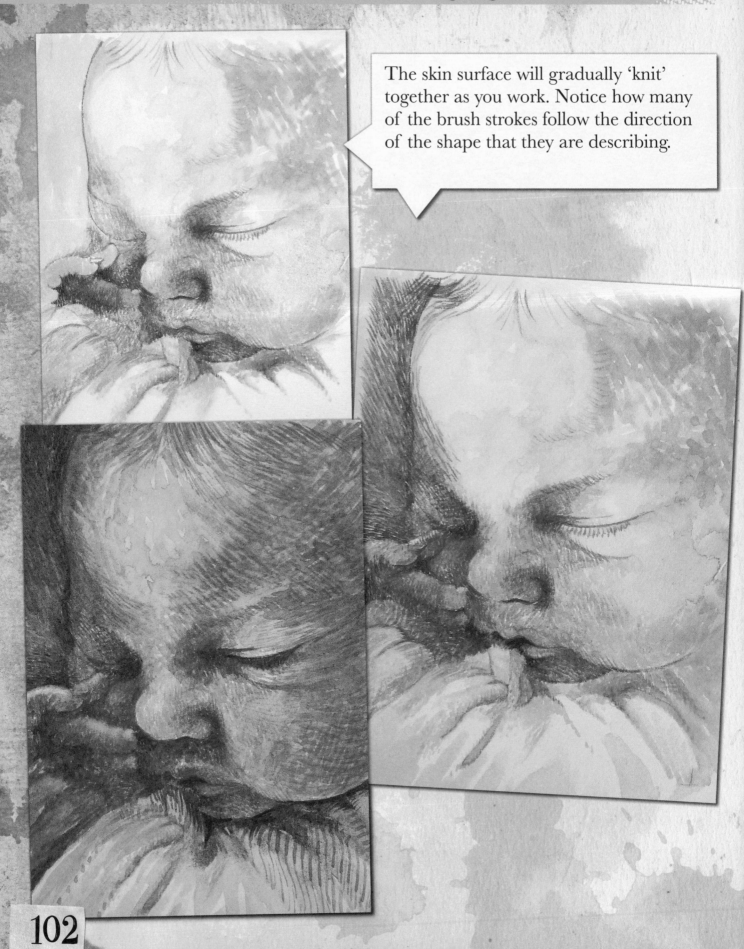

The skin surface will gradually 'knit' together as you work. Notice how many of the brush strokes follow the direction of the shape that they are describing.

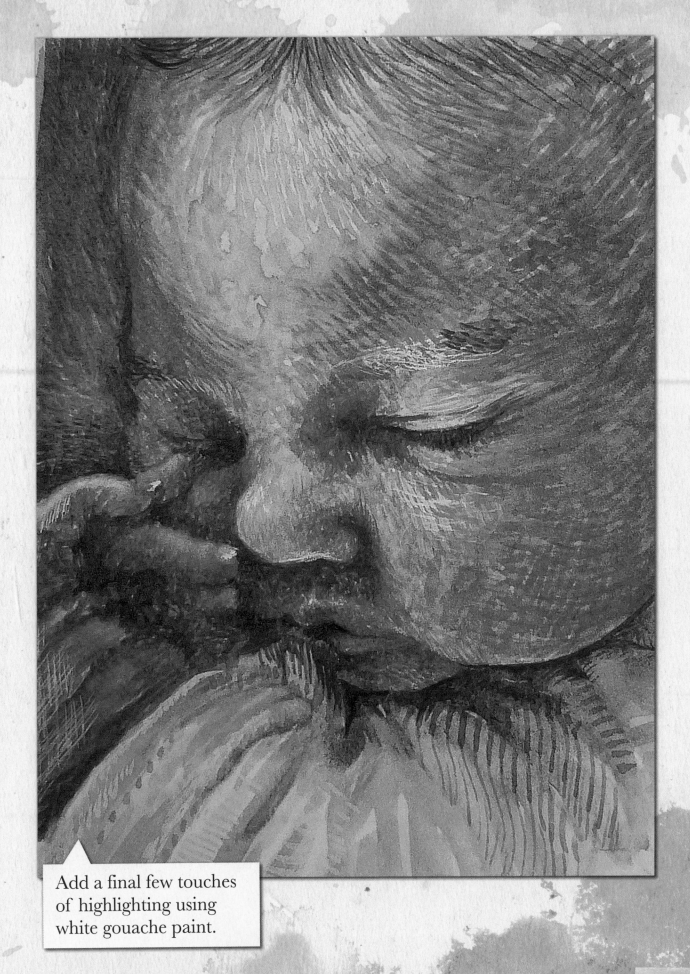

Add a final few touches of highlighting using white gouache paint.

TABLET IMAGE

In order to get used to using the drawing apps, it is helpful to start by doodling with them. Try drawing a figure from your imagination.

Materials:

- Tablet or mobile phone
- A drawing app, I use several: Procreate, Brushes Redux, Art Set, Pen & Ink and Omni Sketch
- Stylus (or use your finger)

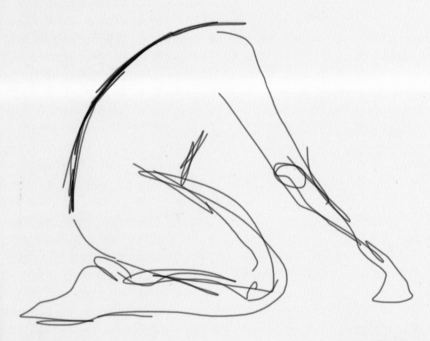

Start by using a thinner brush to draw in the first few lines.

Once you have sketched out the figure, add another layer and move it underneath the drawing, and then add a background colour.

104

ARTIST'S TIP:
The great thing about drawing on a tablet is that you can redraw everything and doodle until you are happy.

Go back to the original layer and start scribbling in tonal areas to 'sculpt' the figure.

Keep adding tone to shadowed areas. This approach is instinctive and with practice you will find it just happens naturally.

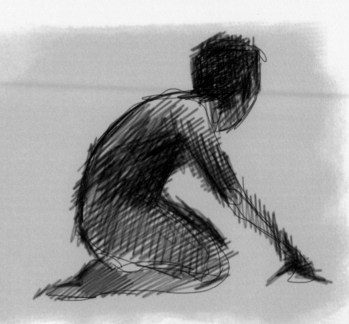

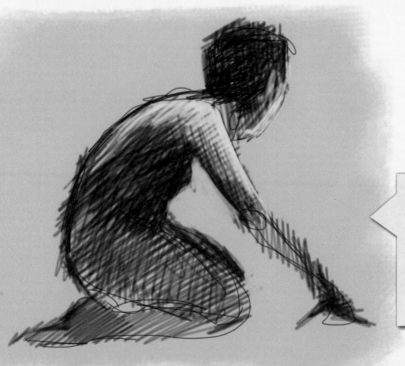

Add yet another layer on top and draw in some highlights to help shape the form of the figure.

105

Go back to the initial image and draw in the other leg.

You can add as many layers as you want to an image using a drawing app. Just keep building it up until you get the effect you want. This image has a top layer and a background layer, but as your confidence builds you can create images that are much more complex.

Top layer

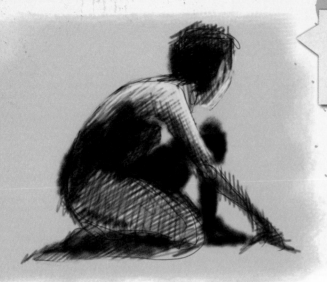

Bottom layer

Much of the figure and the orange background from the last step have been 'overpainted', almost obscuring detail.

106

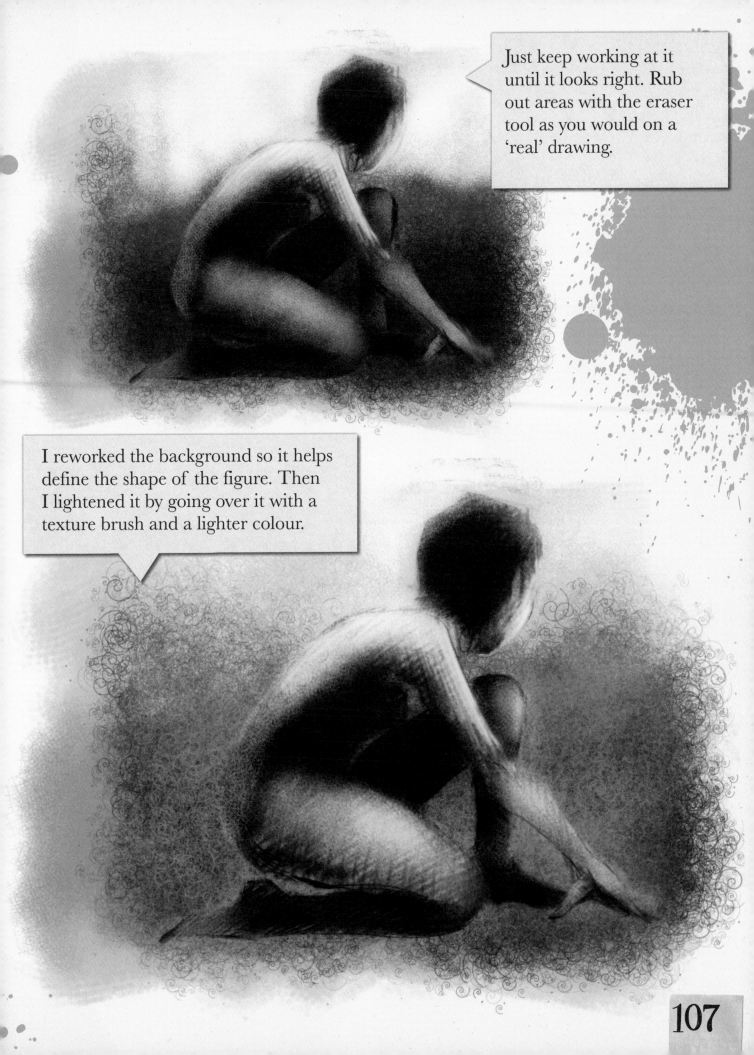

Just keep working at it until it looks right. Rub out areas with the eraser tool as you would on a 'real' drawing.

I reworked the background so it helps define the shape of the figure. Then I lightened it by going over it with a texture brush and a lighter colour.

107

MINIATURES: YOUNG GIRL

Although I love working on a large scale, I also really enjoy painting tiny miniatures. This involves intense concentration and good eyesight (or use a pair of magnifying glasses). With care, you can easily achieve lovely results.

Materials:

- Bristol board (hot pressed)
- B pencil
- Very fine brushes
- Watercolours

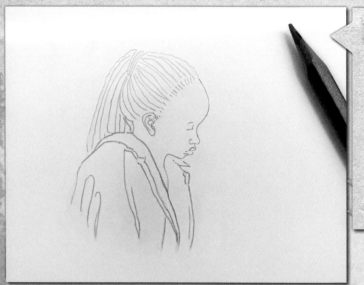

Start with a very precise line drawing. If you don't feel confident enough, make some drawings first, then trace the best one onto the Bristol board hot pressed watercolour paper. It is important to use smooth paper because the paint sits on the surface and doesn't bleed into the paper.

The next step is to paint over the lines of your drawing with a light brown colour, such as burnt sienna. I don't recommend rubbing out the pencil lines as an eraser will fur up the surface of the paper, which will affect the application of the paint.

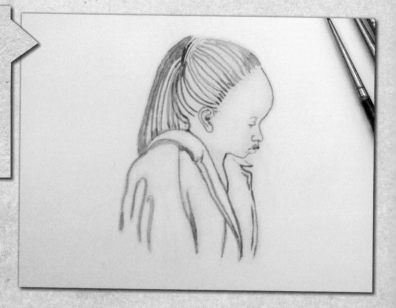

ARTIST'S TIP:
Miniatures are very delicate and really should be framed or at least wrapped carefully with acid free tissue and kept quite dry.

Now dampen the area that you are ready to paint. Don't soak the paper, simply dampen it. Carefully brush clean water over that area only. Then wet the brush again, squeeze the water out, and use the brush to mop up any excess water before you begin painting. Drop in a wash and let it spread across the dampened area. I used burnt umber and some indigo on her forehead and gently 'nudged' them together to blend into a gradual colour change.

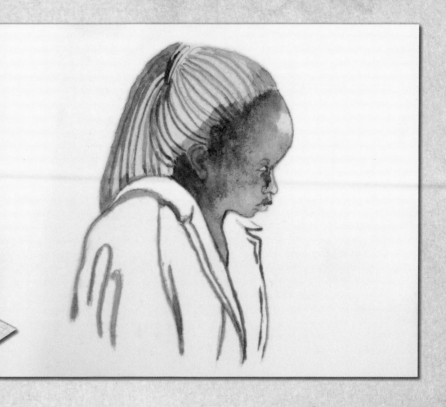

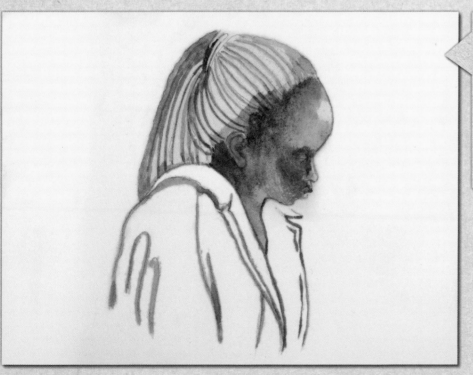

Paint always dries much lighter so start building up the colour with tiny brushstrokes. You might welcome some magnifying glasses by this point!

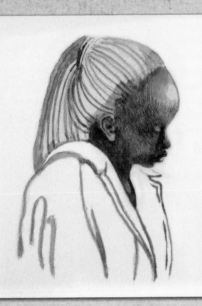

Keep building up the colour with tiny brush strokes. When you load the brush with paint, wipe the ferrule (the metal part above the bristles) on a piece of cloth. Try not to overload your brush, as this may result in the brush unexpectedly releasing a blob of paint onto your tiny brush strokes.

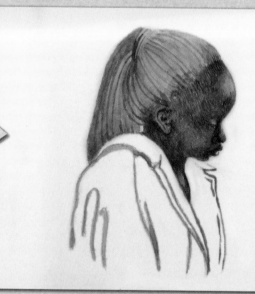

Now paint over her hair using an indigo blue wash. This base layer will become the highlights for her dark hair. As with all watercolour painting, you work from light to dark.

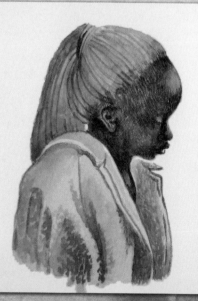

Now start underpainting her coat. Use the indigo blue again to add a wash of colour. Once dry, add blue shadows.

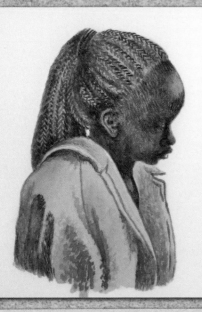

Build up the braid patterns in her hair following the lines you first drew. Notice how the braids are well defined where the light hits them but fade to dark. The detail is not constant.

Add some warmer colours now, like raw sienna and raw umber. Notice how the blue shadows on the coat change colour as you layer the washes.

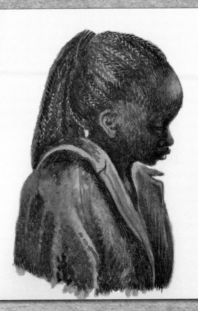

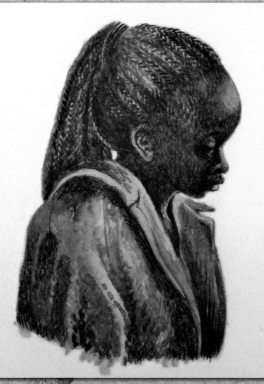

Finally, with a clean damp brush, gently wash away some highlights. Be very careful not to overdo it though.

MINIATURES: PORTRAIT

With a bit of practice you can paint a miniature with little more than controlled washes to create a really tiny watercolour, using a mixture of techniques.

Materials:

- Smooth Bristol board
- B pencil
- Very fine brushes
- Watercolours

Lightly pencil in as few lines as possible to flag up crucial elements of your drawing. Try making several sketches first to work out the vital lines that will guide your painting. Then trace and transfer them onto the Bristol board. Start by painting in the eyes – if these are wrong then nothing else will work! Don't be tempted to use black but build up with dark blues instead. My favourite mixture is of phthalo blue, alizarin crimson and perylene green. Use delicate washes, allowing each one to dry in between.

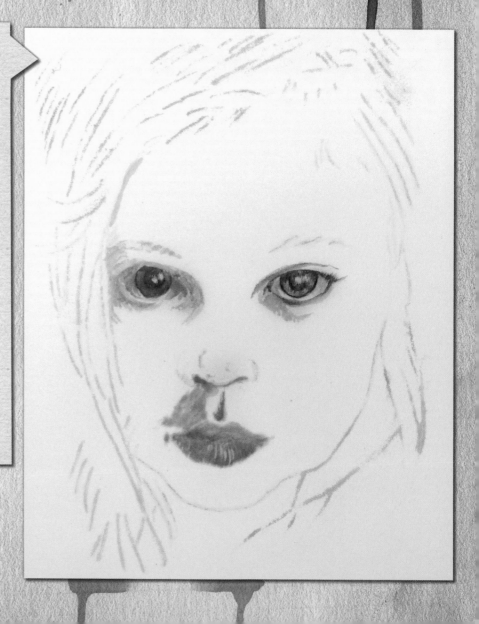

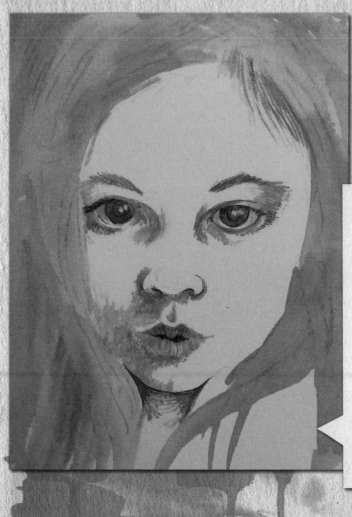

ARTIST'S TIP:
When painting a child or young person, use a very light touch to keep the freshness of their features.

Add a wash of yellow ochre for the hair and carefully start to define the features. Adding a touch of the yellow ochre wash to the iris changes its colour from blue to green. It is important to lose outlines, especially when painting children. With all portraits you must think about lost and found edges instead. This is when shape is subtly defined by its background or adjacent colour. Think of shape rather than lines – your eye will naturally 'bridge the gaps' to interpret your painting.

A hard edge is a sharply defined edge whereas soft edges are blurred and out of focus, creating a gradual tonal change. A lost edge is a softly dissolved edge. If a face is in shadow against a dark background, you as the viewer know that the face has a cheek and jawline, yet the artist hasn't painted it at all – it has been lost in shadow. A found edge is one that has been 'drawn' by the tonal contrast between two objects, like a light cheek against dark hair for example. Shape is shown by its tonal mass rather than by line.

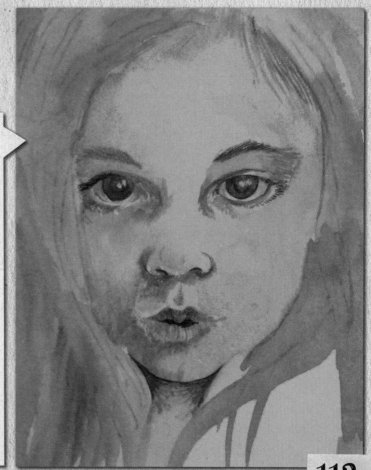

Warm the skin tones with a pale wash of very light yellow ochre with a tiny bit of opera rose and a little burnt sienna. Dampen the area first, allowing colours to mix gently on the paper. Dab in a little more colour where necessary.

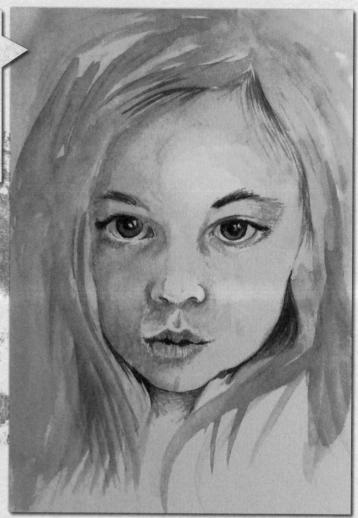

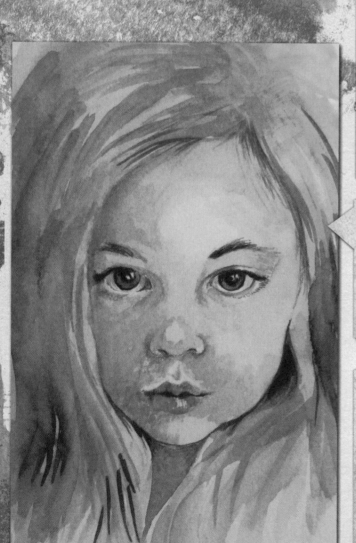

When dry, add another couple of layers of wash to the skin tone to add a very slight shadow (or darker tone) to the left side of the face. Work into the darkest areas with delicate washes of burnt umber.

Add warmth to any areas that you think need some depth of colour. I added touches of burnt sienna to the hair and a little around the mouth and on the lips, always leaving highlights clear. Use white gouache to add a few light strokes to the hair and a soft tiny highlight on the tip of the nose.

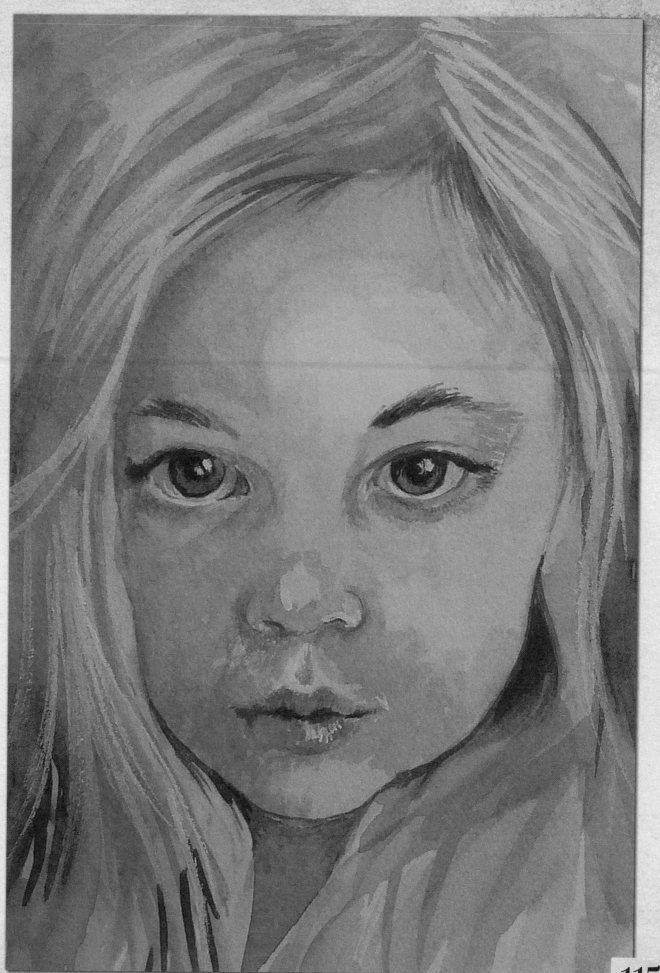

LINO PRINTING

Lino printing is good fun and is a relatively easy print-making process that can be done at home with very little equipment. You cut out areas that you don't want to print, and the remainder is inked for printing.

Materials:

- Lino block
- Cutting tool and knives
- Lino waterbased ink
- Brayer
- Spoon
- Try different types of paper – slightly absorbent thinner paper works well.
- A baking tray or piece of glass to ink up the roller

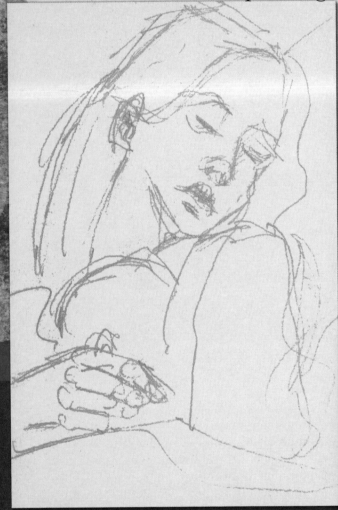

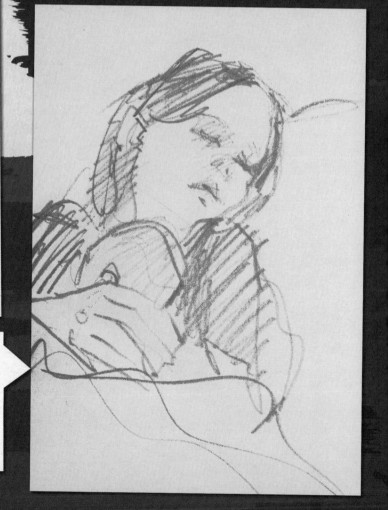

Use a drawing from your sketchbook or do a completely new drawing for your lino print. I had a few sketches of my daughter asleep with her newborn son that I thought might make a nice print.

If you warm lino on a radiator or with a hair dryer you will find it is much easier to cut.

When cutting into a lino block, the lines have to be fairly bold. I made my drawing more stylised to simplify the lines and then went over them with a thick felt-tip pen. Using a thick pen tends to cut out any unnecessary detail.

Copy or trace your design onto the lino block. Printed images are always in reverse – a mirror image of what you draw. If you include any words in your design, they too must be drawn in reverse.

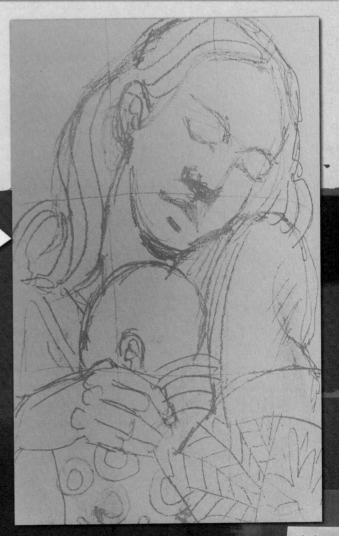

LINO PRINTING PART 2

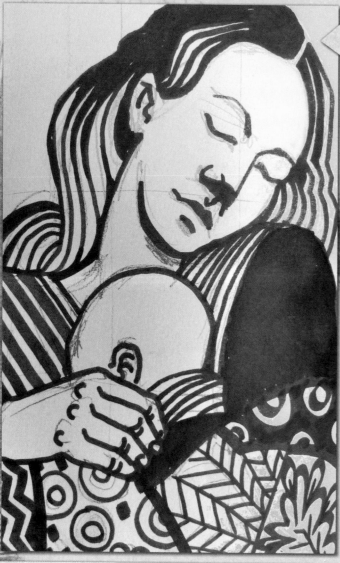

Now go over the pencil lines with a thick felt-tip pen. Draw in areas of patterning.

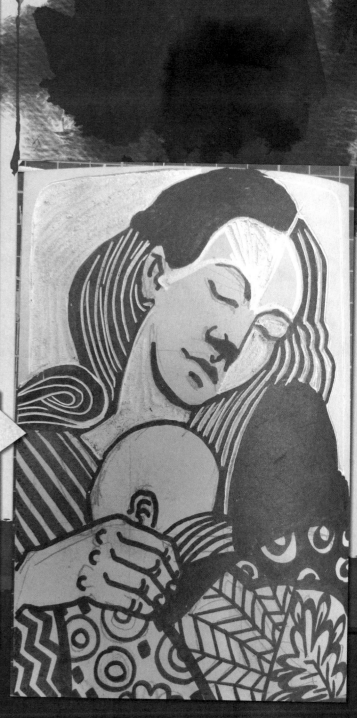

Start cutting away the white areas. The black areas will be inked-up for printing. Work slowly and always cut away from yourself. Don't gouge too deeply or your lino tool may slip – it's better to go back and cut more away, if required. You need to apply enough pressure to cut and to control the direction of the cutting line. Try not to slip as you may cut yourself… and ruin your work.

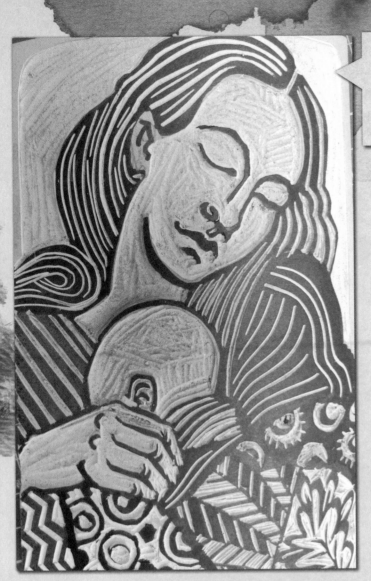

Turn the lino as you work so that you are always cutting away from yourself and working from the easiest angle.

When you have finished cutting, squeeze some water-based ink onto your inking surface.

Roll out the ink so it is not too thick or too thin. As the roller moves back and forth it should sound a bit tacky.

Now ink up your lino block. Keep working the roller across the surface of the block until the ink is evenly distributed.

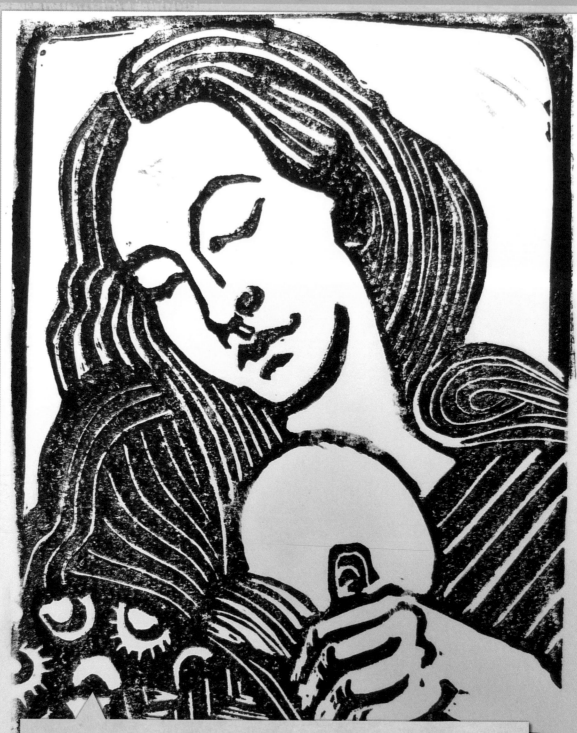

Carefully place your paper on top of the inked block and tape the corners down to stop it moving. Now burnish the surface with a spoon. Using a circular motion, press the paper down onto the printing block. Carefully peel the paper off to see the transferred print. To print again in a different colour you must first wash the ink off the lino block, roller and inking surface.

121

CHARCOAL LIFE DRAWING

Working in charcoal with your fingers or a paper stub and a putty rubber is a very nice way to work. It's hard to make a mistake as you can go back and re-work areas very easily. It's a bit messy but if you relax it's good fun to get really stuck into your drawing.

Materials:
- Cold pressed watercolour paper (300gsm)
- Large wash brushes
- Brown ink or watercolour
- Torchon paper stub
- Compressed charcoal
- Chalk
- Putty rubber

Paint the paper with brown ink or a brown watercolour wash to give your drawing a warm mid tone. Then rub charcoal all over your paper, blowing away the loose dust.

Rub the charcoal to make a dark charcoal page.

ARTIST'S TIP:

If you concentrate on the light falling on shapes you might be able to find the proportions of a figure more easily.

Mould the putty rubber in your hands. Making it warm will let you shape it into a drawing point. Then use it to start taking away the lightest parts of the figure.

When you are happy with your figure, start to define some of the darker areas that you can see with the compressed charcoal.

Working out from the light, draw the shape of the stool. If you think you have made a mistake, just add more charcoal, rub it in and start again with the putty rubber.

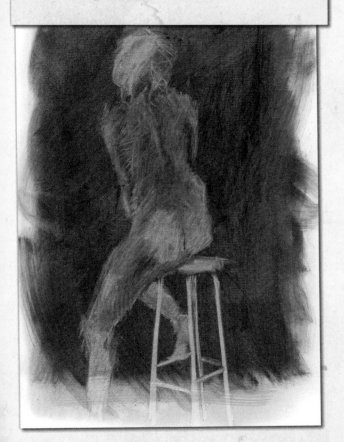

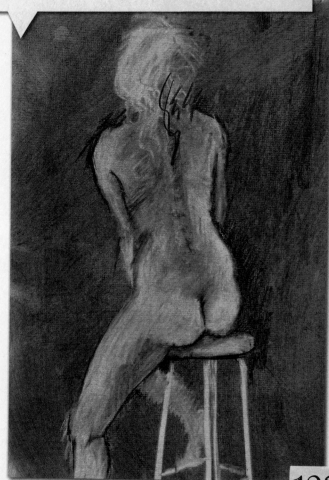

123

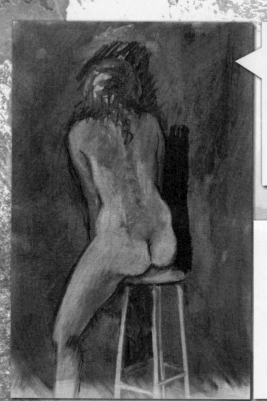

Now build up a solid form with the chalk, re-emphasising lighter areas with cross hatching, following the form again.

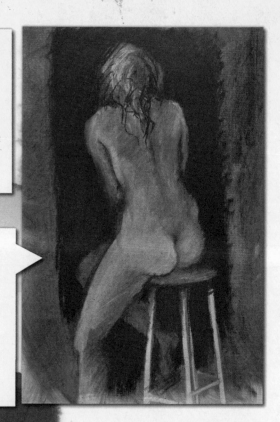

Work back and forth between the rubber, chalk and charcoal until you have the intensity of drawing that you want.

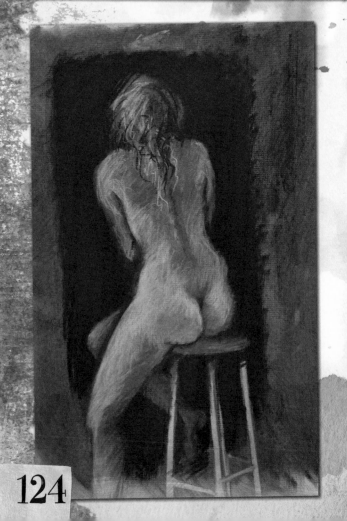

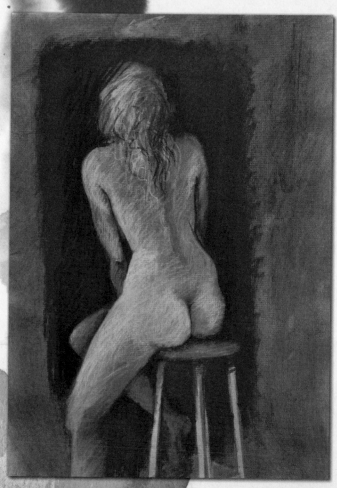

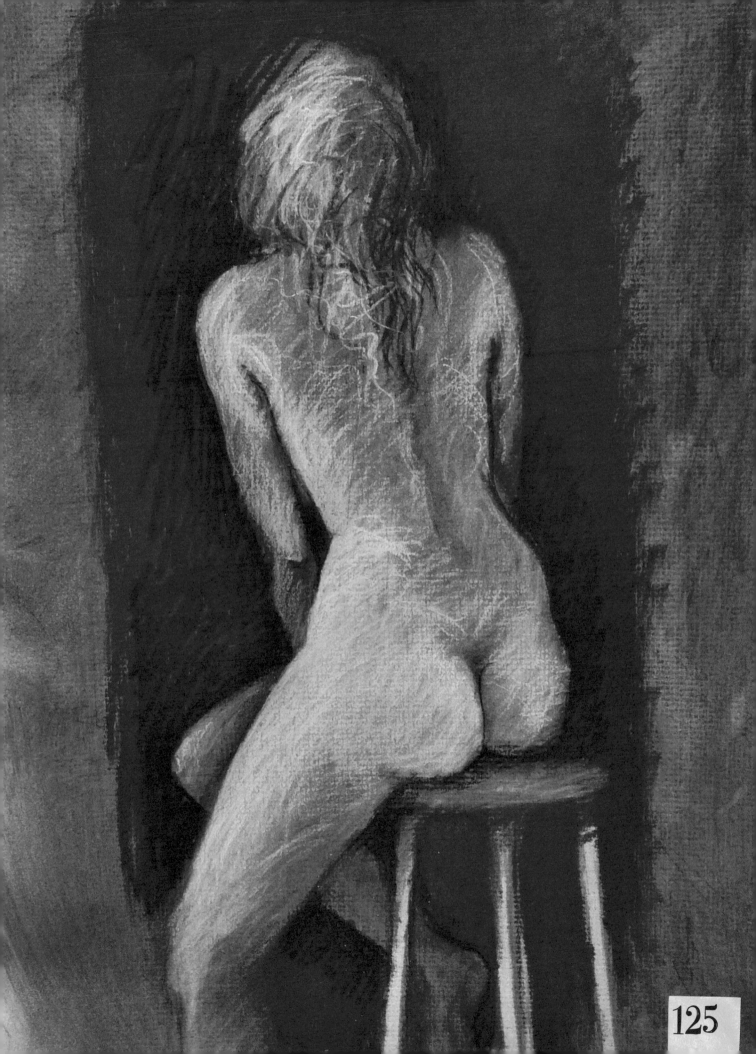

GLOSSARY

Anatomy The internal structure and component parts of a living organism.

Background Areas of a drawing or painting that are furthest from the viewer.

Blending Gently rubbing an area of shading or colour with a blending tool (a paper stump) to create a gradual transition from one to the other.

Blind contour Single line drawings produced by looking at the subject – not the paper.

Canvas Cotton or linen fabric that must be stretched and primed for acrylic or oil painting.

Colour wheel The organisation of colours on a wheel. Used to help understand colour schemes.

Composition The arrangement of parts of a drawing within the drawing space.

Contour The outline of something.

Contre-jour An artistic effect where the light source is behind the subject of a drawing or painting.

Cross-hatching A shading technique using two or more sets of intersecting parallel lines.

Depth The apparent distance between front and back areas of artwork.

Figure The human form in art work.

Foreground The section of a drawing or painting that is nearest to the viewer.

Gouache Watercolour paints mixed with white pigments, making it more opaque and giving it more weight and body.

Graphite A form of carbon that is used in pencils.

Highlights Small touches of white in a drawing or painting used to show the reflection of light.

Line The most basic drawing 'tool'. A line has length, width, tone, and texture. It can divide space, define a form, describe contour, or suggest direction.

Linear A drawing or a detail in a drawing constructed from a single, unbroken line. Can also refer to a picture drawn in a series of steps progressing one after the other without returning to earlier stages of the process.

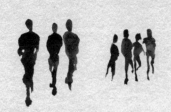
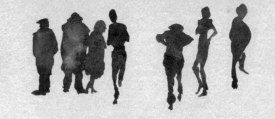
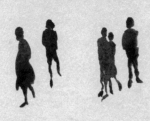

Linen A cloth made from fibres of the flax plant. It is a very absorbent material.

Medium Materials used to create a work of art.

Negative space The space that surrounds an object in an image.

Palette A thin board for mixing colour or the range of colours used in an artwork.

Paper torchon A type of paper with a coarse surface structure that can be used to blend and rub the marks in a picture.

Perspective A way of portraying three dimensions on a flat, two-dimensional surface by suggesting depth or distance.

Quill A pen made from a feather. The hollow stem of the feather is dipped in ink and then scratched across a surface.

Scale The size ratio between parts of an image. Using a scale allows the size relationships between objects to appear real or believable.

Sketch Quick, rough drawing without much detail that can be used as a plan or reference for later work.

Spray fixative A transparent aerosol that is sprayed onto artwork to help prevent smudging.

Texture The visual 'feel' created in a two-dimensional artwork, or the way a three-dimensional work actually feels to the touch.

Tint When a slight colouring is applied to a material such as paper.

Tone The degree of lightness or darkness in an artwork. Tone varies from the whiteness of a light source through shades of grey to the deepest black shadows.

Wash A thin coat of diluted paint or ink applied to the surface of a painting.

Watercolours Water-soluble paint that provides a slightly transparent colour when applied to a canvas or paper.

INDEX

A
angles 18, 66, 119
app 96–99, 104–107

B
background 43–44, 78, 90, 96, 101, 104, 106–107, 113, 126
beards 41, 85
blending 23, 27, 71, 94–95, 109, 126
blind contour drawing 68, 76–79, 126
brushes 13, 32, 34, 47, 52, 54, 64–70, 72, 80, 84, 88, 92, 96, 98–102, 104, 107–112, 122

C
chalk 27, 36–37, 122, 124
charcoal 26, 36–37, 46–47, 122–125
colour
 blocking 47–48, 51, 57, 65, 70–72, 88, 93, 95–97
 contrasting 53, 113
 mixing 27–28, 30–31, 47, 50, 56, 68, 73, 80, 87, 90–91, 101, 112, 114, 126
 layers 27, 48, 51, 61–62, 73, 88, 90, 96–99, 101, 104–106, 110–111, 114
 wheel 28–29, 126
composition 46, 56, 63, 126
crosshatching 37–38, 98, 100–101, 124, 126

D
depth 16, 39, 114, 126
distance 17, 29, 126
doodling 35, 66, 69, 80–81, 84, 104–105

E
ears 17, 38, 40, 84
easels 20

eraser 22, 107–108
eyes 17, 38, 69, 72, 84, 94, 112

F
feet 33, 35
fixative spray 26, 127
foreground 58–59, 126

G
gouache 13, 70, 103, 114, 126
grid 31, 46, 50, 56

H
hair 13, 17, 43–44, 64–66, 68, 84–85, 90, 93, 110–111, 113–114
hands 18, 33–35, 65–67, 70–71, 89
highlights 38, 44, 52–53, 58, 62, 71, 91, 93, 99, 103, 105, 110–111, 114, 126

I
ink 13, 24–25, 34–35, 54, 64–67, 70, 85, 92–93, 116, 118–120, 122, 127

L
light 39, 52–58, 61, 94, 111, 123

M
mouth 17, 84, 114

N
negative space 54–55, 94, 126
nose 17, 36, 38–39, 69, 72, 84, 86, 114

O
oil paints 32, 46–48, 50, 52, 56, 58, 126

P
palettes 28, 126
patterns 24, 47, 69, 73, 85, 90–91, 98, 111, 118
pencils 9, 13, 15–16, 18–19, 22–23, 34–35, 38–42, 44, 46, 60–61, 66, 70–71, 74–78, 84–85, 88, 92, 94, 100–101, 108, 112, 118
pens 9, 13–15, 24–25, 34, 66, 75, 84–85, 117–118, 127
perspective 62, 67,126
photographs 33, 54, 56, 64, 66, 72
portrait 33, 42–44, 46–52, 87, 113
proportions 16–17, 35, 38, 123

S
scale 17, 80, 127
shading 41, 55, 67, 126
shadow 38, 40, 50, 53, 56, 58, 69, 71–72, 88, 93, 97, 105, 110–111, 113–114
sketchbook 9, 14, 18–19, 24, 66, 70, 75–76, 116
surfaces 14, 39, 53, 100, 102, 108, 119–120

T
tablet 96–99, 104–107
texture 53, 58, 88, 98–99, 107, 127
tone 27, 30, 36–38, 42–45, 53, 57, 60–61, 72, 91, 97, 105, 114, 122, 127

W
watercolour 13, 15, 30, 32, 34, 56, 64, 66, 68, 72, 74, 80, 82, 84, 86, 88–89, 91, 100, 108, 110, 112, 122, 127